IMAGES
of America

THE HUMBOLDT
WAGON ROAD

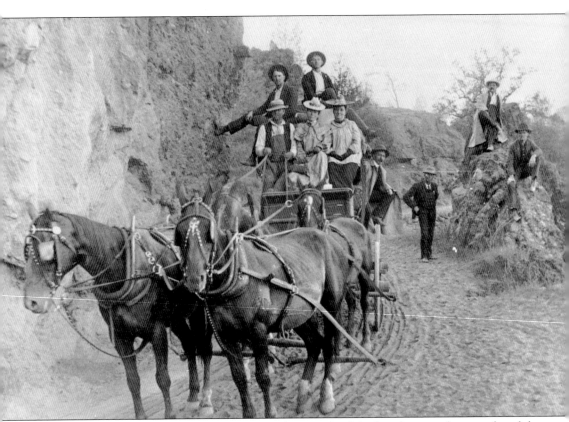

THE COUNTY SEAT GRADE. Taken in 1904, this is one of the best-known photographs of the Humboldt Wagon Road. When Chico tried to wrest the title of county seat for Butte County from Oroville, 100 men were hired to work on the road in exchange for a vote in favor of Chico. Their votes were thrown out. Oroville retained the honored designation. (Courtesy of John Nopel collection.)

ON THE COVER: A TURNING POINT IN TECHNOLOGY. The historic Humboldt Wagon Road, built in the 1860s, has evolved to the Humboldt Road still in use today. This undated photograph shows the milestone changes that have taken place on it over a time period that spans three centuries. "Our horse, Old Joe, was hitched outside, and I know dad wondered what in the world Old Joe might do if there was an automobile came up behind him," said 14-year-old Elsie Bidwell Bumgarner in 1904. (Courtesy of John Nopel collection.)

IMAGES
of America

THE HUMBOLDT WAGON ROAD

Marti Leicester and David Nopel

ARCADIA
PUBLISHING

Published by Arcadia Publishing
Charleston, South Carolina

Printed in the United States of America

Library of Congress Control Number: 2011927435

For all general information, please contact Arcadia Publishing:
Telephone 843-853-2070
Fax 843-853-0044
E-mail sales@arcadiapublishing.com
For customer service and orders:
Toll-Free 1-888-313-2665

Visit us on the Internet at www.arcadiapublishing.com

To our fathers, Henry Leicester and John Nopel,
who inspired in us our love of history

CONTENTS

ACKNOWLEDGMENTS

The idea for this book began when John Nopel started collecting research and photographs about the Humboldt Wagon Road. We regret he is not here to share our excitement about this publication. Pheleita Nopel, John's wife, fellow collector, and David's mother, shared her memories throughout the past year, helping us feel connected to John's thoughts.

Our spouses, Ron Kaufman and Betty Nopel, were extraordinarily patient and unfailingly supportive. Cynthia, Adam, and Ryan Moore, and Mindy, David's dog, cheered us on weekly. Thank you so much!

By sharing her extensive research and photographs, Anita Chang made this book possible. Andy and Jill Mark introduced us and took us on the road. For first suggesting the idea, thanks go to Doug Patterson and to all the BEEP buddies who hosted Story Night.

To those we interviewed, your memories have provided material for many more books! Thanks go to Jim Crane, Shirlon Dodge, Cliff "Blackie" Gilbert, Dan Heal, Jack Lucas, Delores McHenry, Barbara Greene Maggi, Lynn Marks, Tom Marks, Elizabeth Mohr, Beverly Benner Ogle, Gene and Dorothy Rolls, Elwin and Wally Roney, Emma and George Roney, Aileen Selvester, Lisa Speegle, Ren Wakefield, and Arlene Ward.

For research and review assistance beyond the call of duty, we thank Peggy Arms, Susie Bromley, Diane Camp, Jan Dawson, Sara and Sean King, Guida Leicester, Henry Lomeli, Dr. Michael Magliari, Jeff Mott, Marilyn Quadrio, Randy Taylor, Bob Thomas, Gretchen Vandewalle, Richard Vaughn, Ann Verzi, and Zu Vincent.

Resources in libraries and museums were invaluable. We thank the Association for Northern California Research, Jim Jessee; Bancroft Library; Butte County Historical Society, Dale Wangberg,; Butte County Public Library; California State University, Chico, Meriam Library, Special Collections, George Thompson, Pam Bush, and Deborah Besnard; Caltrans Transportation Library and History Center, Diane Voll; Chester-Lake Almanor Museum, Joan Sayre; Idaho State Historical Society; Lassen County Museum, Janet Corey; Plumas County Museum, Scott Lawson; Society of California Pioneers; and Ted Huang, University of California, U.C. Berkeley Extension.

Everyone in the Butte Meadows-Jonesville Community Association and Forest Ranch Women's Club, Community Association and Charter School, fueled our efforts.

Arcadia editor Coleen Balent kept us on track.

Thank you, everyone!

INTRODUCTION

In 1863, the Humboldt Wagon Road started from a commercial hub, called "the Junction," in the newly formed city of Chico. It ran about 100 miles east to the city of Susanville. This is the story of how it came to be and what has happened on the road over a time period spanning three centuries.

John Bidwell, an early California pioneer and the founder of Chico at the western end of the Humboldt Wagon Road, played a leading role in this story. He conceived the idea of the road, procured the funding, and maintained it throughout his lifetime. Just as importantly, from the vantage point of today, were the indigenous people who were pushed aside by the road and struggled to maintain their culture in spite of brutal efforts to destroy them during the settlement of Butte County. We can learn caution from this history and gain inspiration from the many accomplishments it records.

We invite the reader to "ride the road" through these images, stopping along the way in the communities that grew up along the route, meeting people who lived there, and learning what it takes to make a road and how a road can make a place.

We introduce you to some narrators who have lived the recent history of the road. Clifford "Blackie" Gilbert grew up in the West Branch and Butte Meadows lumber camps. Barbara Greene Maggi is descended from hotel operators at Jonesville. Jack Lucas's family still lived at their homestead along the road while he was growing up. Beverly Benner Ogle grew up with her Maidu grandmother learning her culture's stories and traditions. The "ranching Roneys," husband and wife, George and Emma Roney, and Elwin Roney and his son Wally talked to us about the livestock history of the road. Aileen Selvester, Shirlon Dodge, and, of course, Penny and David Nopel recounted many stories about their families' long tenures in Forest Ranch. Though they are gone, friends and family of the Dorrett and Wilson families, the Ruffas and Tartars, and of Anna Marks recalled their lives with many wonderful photographs.

It is hard to imagine today how difficult it was to travel through what are now the states of California, Idaho, and Nevada. The region was separated from the rest of the nation by geography and climate—the Great Plains, deserts, mountains, and extreme weather conditions. Indian tribes, alarmed at the growing encroachment of Euro-Americans on their lands, provided, at times, a hostile reception. Still, the rich natural resources beckoned people to journey West, and they poured into the Pacific Coast territories. Following this influx came nearly simultaneous political commitments to establish a national wagon road and a transcontinental steam-powered railroad. Both these competing ideas for a national transportation network were intended to link with the growing West Coast steamship industry to extend the reach of land-based transportation systems.

John Bidwell arrived in 1841 in what was then Alta California, a region governed by Mexico. Seven years later, Bidwell "struck it rich" during the California Gold Rush and used his newfound wealth to purchase Rancho Chico, a large Mexican land grant, of about 22,000 acres. He played a leading role in gaining California statehood in 1850 and developed a successful commercial agricultural enterprise on Rancho Chico. In 1860, he founded a new community, Chico, on a

portion of his property in the northern Sacramento Valley. Always forward looking by nature, Bidwell was one of those who recognized the gains to be made from an expanded western road system. His geographical knowledge of the region, the expanding opportunities for his own business, and his involvement in state politics provided the impetus for him to take the risk to develop the Humboldt Wagon Road.

Though few could fully envision the coming impact of a steam-powered machine age, railroads had already claimed the future of American land transportation. Earlier, successful eastern railroad building activity inspired western representatives to lobby for federal assistance to bring railroads to the frontier. By 1856, federally funded surveys identified five primary transcontinental railroad routes. The surveyors favored a "central route" to Sacramento on which trains would travel into California via the Honey Lake Valley, near the town of Susanville, and then south to Sacramento.

While Californians were debating future railroad lines, many in the country, including many Californians, still saw draft animals and wagons as the only practical way to move across America's vast interior. In 1855, the California Legislature passed a law to construct a wagon road from Sacramento, east to the state line just north of the Carson Valley, today's Reno, Nevada. In 1857, the federal Military Wagon Road Act required that the western end of a National Military Wagon Road be at Honey Lake near Susanville. This law encouraged dozens of road surveys for the state, and local communities fought fiercely for financing to fund the wagon roads that would bring money to their coffers. In response, California created a State Board of Wagon Roads.

The biggest challenge for developing either railroad or wagon roads was always financing. In 1859, the Nevada Comstock Lode discovery was made just east of the Carson Valley, about 180 miles east of Chico. A new mining rush to that area generated more California roads. The State Board of Wagon Roads granted toll-collection franchises to private firms that constructed new roads or maintained existing ones.

In 1863, John Bidwell and his partners J.C. Mandeville, R.M. Cochran, and John Guill put up $40,000 and applied to the California State Legislature for a franchise to construct a toll road between Chico and Honey Lake. Their application was approved. In 1864, they incorporated as the Chico and Humboldt Wagon Road and completed road construction. Their initial plan was for a road that would reach Susanville and connect with the planned National Military Wagon Road.

Their plans soon expanded. In 1863, Michael Jordan and a group of prospectors discovered gold about 400 miles from Chico, located along Jordan Creek in the Owyhee Mountains and the Boise Basin of the Idaho Territory. Yet another gold and silver rush fueled additional western settlement and, for John Bidwell, opened a second potential outlet for his trans-mountain Humboldt Wagon Road project. Bidwell saw a promising future for Chico as a major link in a supply line that reached from San Francisco and the Pacific Coast, up the Sacramento River by steamboat to Chico Landing, where wagons could then carry goods on an almost direct overland route to Susanville, and on to the rich mining camps of Nevada and Idaho.

Meanwhile, impelled by the initial gold discoveries of 1863, three Idaho men initiated an attempt to build a connection between Chico and Ruby City, which was extended a little later to Silver City, Idaho. In the winter of 1864–1865, J.B. Francis of Boise; E.D. Pierce, a successful miner; and G.C. Robbins, superintendent of the New York and Owyhee Gold and Silver Mining Company, formed the Idaho Stage Company. Pierce met with Bidwell in January 1865 to explore the feasibility of a stage line from Chico to Idaho. Robbins approved their proposed route. Bidwell and other wealthy ranchers in the area provided Francis and Pierce with equipment and money for stagecoaches to begin running. The first saddle train left Chico on April 3, 1865, and arrived in Ruby City, Idaho Territory, 27 days later. Unfortunately, the Idaho line did not succeed financially. Road maintenance was expensive and inadequate. At points, the stage traveled through hostile Indian Territory in Nevada and Idaho, which scared off passengers.

Nevertheless, Hill Beachy, another Idaho resident and former Californian, also became interested in operating a stage line from Idaho to Nevada. He developed a route that connected, in part,

with the Humboldt Wagon Road. Unfortunately, after just one month of operation, in June 1865, he also gave up after having two stagecoaches burned in Indian raids.

Following the failed starts in 1865, interest in developing stagecoach lines declined in Idaho but increased in Chico, as the value of the Nevada and Idaho mining profits continued to grow. At that time, John Bidwell had been elected to the US House of Representatives. In 1866, he helped secure a mail contract for the route between Susanville and Ruby City and between Susanville and Chico. In May 1866, John Mullen, a well-known road builder who had joined the Idaho Stage Company the year before, came to Chico to once again establish a stagecoach line under the newly named California and Idaho Stage and Fast Freight Company. Operations got off to an encouraging start. Crews working from both the Idaho and California ends put the road into shape. The passenger schedule did indeed start from Chico to Susanville on June 20, 1866, and the mail runs started at midnight on July 1 when the new contracts went into effect. Things went well until the following winter when heavy snows began to interrupt regular mail delivery to Ruby and Silver cities. The post office cancelled the contract, and in March 1867, the *Chico Courant* reported that the stock and equipment of the California and Idaho Stage Company had been sold.

Bidwell's vision of Chico as a major western transportation center ended on May 10, 1869. On that date, the Central Pacific Railroad met the Union Pacific at Promontory, Utah, completing construction of the nation's first transcontinental railroad. The course of America's transportation future was set. Long-distance wagon transportation went into rapid decline.

The Humboldt Road, however, remained in operation and was still an important factor in the region's subsequent development. At either end, Chico and Susanville continued to grow. Passengers, cowboys, and freighters continued to travel the road, stopping along the way for rest, water, and refreshment at Hog Springs, 10-Mile House, 14-Mile House, Berdan's, Jonesville, Ruffa Ranch, and Faniani Meadows. Lumber towns grew near the road at West Branch, Lomo, Chico Meadows, and Butte Meadows. Some places, like Forest Ranch, Big Meadows, and Prattville, became established communities.

During the 1870s, loss of trade with the gold and silver mines of Idaho and Nevada was offset by the development of the Sierra and Cascade lumber industry. Horse-drawn freighting and passenger service thus continued on the road into the first two decades of the 20th century, when gasoline, rather than hay, began fueling the new horsepower of the automobile.

Locally funded maintenance on the Humboldt Wagon Road had continued since its official designation as a state wagon road in 1863. In 1933, the now graveled Humboldt Road was adopted into the state highway system as State Route 47, a secondary state highway from Chico to Lomo, which was a distance of about 25 miles. Several sections consisted of paved lanes, sometimes only 15 feet in width, while others were merely oiled roadway over gravel. Meanwhile, the right-of-way began to deviate in some sections from the historic wagon road.

By 1914, most of the Big Meadows area and the town of Prattville, stops on the road between Butte Meadows and Susanville, had been submerged under the waters created by the Lake Almanor dam, cutting off the connection to Susanville. Meanwhile, the Red Bluff-Susanville Road, now Highway 36, underwent a series of improvements leading to its superseding the old Humboldt Road.

In 1935, a new stretch of State Route 47 was built in order to restore this vital trans-mountain link. In addition to an improved roadway, it serviced the newer, larger logging industries in Westwood and Susanville and encouraged tourism to the recently established Lassen Volcanic National Park. This new section of Route 47 ran through the Deer Creek Canyon between Lomo and State Route 36, connecting to the town of Chester, the successor community to the inundated Prattville.

By 1955, new plans were to improve again what had become the narrow, dangerous, and crumbling State Route 47 and transform it into the improved and renumbered State Route 32 (still known, like its predecessor, as the Deer Creek Highway). Over a 15-year time span, this new highway was straightened, widened, striped, and signed.

During the 20th century, development along the road was determined more by the needs of the automobile and truck than by the horse and wagon. Chico continued to grow, still holding its place as the largest and most economically diverse city on the Humboldt Road. Other places also prospered and remain, while some faded away.

Things are not always what they seem. Bidwell's plans for the Humboldt Wagon Road did not turn out as he hoped, yet the road played a significant role in bringing some of the commercial success he wanted for the area. For Native American people, this "success" was part of a juggernaut of change that almost destroyed them, yet they adapted and today are rejuvenating their cultures. Through this pictorial history of the road's past, perhaps we might enrich our ideas on unexpected ways to move toward our common future.

One

A GRAND PLAN

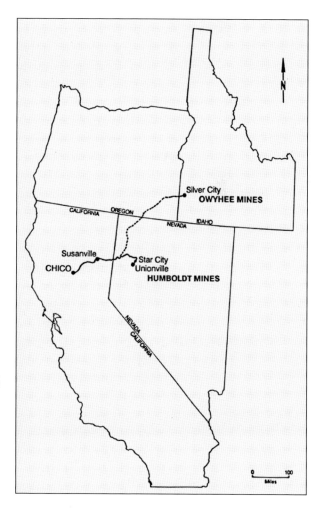

HUMBOLDT WAGON ROAD ROUTES, 1865–1867. The Chico to Susanville section was built by John Bidwell and his partners. The Ruby/Silver City section was initiated by E.D. Pierce, J.B. Francis, and G.C. Robbins for the Idaho Stage Company. Hill Beachy opened a separate route to the Nevada Humboldt mine area. (Courtesy of Anita Chang collection.)

11

LOOKING WEST FROM HUMBOLDT ROAD. This 1992 view looks down on modern-day Chico. The undeveloped oak woodlands in the foreground were familiar to Valley and Mountain Maidu Indians. They would have hunted game or collected acorns, bulbs, and other foods there. In the distance can be seen how the original wagon road evolved over time to become old State Road 47 (left) and today's State Highway 32 (right). (Courtesy of Anita Chang collection.)

BIG CHICO CREEK CANYON, 1903–1904. The road follows a ridge where the Sierra and Cascade mountain ranges meet. As freight wagons and stages climbed the road out of Chico, they would get beautiful canyon views. (Courtesy of California State University, Chico, Meriam Library, Special Collections.)

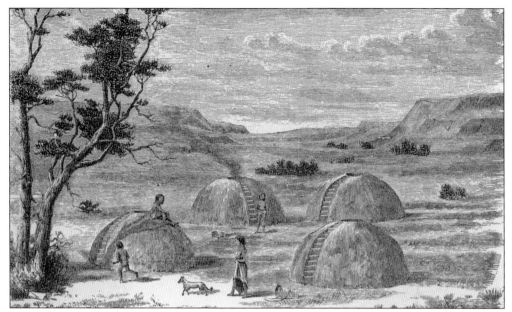

VALLEY MAIDU. For many centuries before Europeans arrived, Maidu Indian tribes lived in the area currently consisting of California's Butte and Plumas Counties. The Mechoopda, or Valley Maidu, lived around the area that eventually became Chico. Their villages, located near the area's numerous waterways, disappeared as they lost their lands to new settlers. (Stephen Powers, author; Robert F. Heizer, contributor. Tribes of California. "Earth Lodges of the Sacramento Valley, 1877.")

HUBO AT BIG MEADOWS. The Humboldt Road crossed the lands of the Mountain Maidu where their homes, similar to this, were grouped in family or village clusters. Support poles were overlaid with cedar bark; tree moss filled the cracks to make sturdy, well-insulated dwellings. A sign has been placed at the top of this *hubo* (meaning "home" or "dwelling"), but the rest of it is traditionally built. (Courtesy of John Nopel collection.)

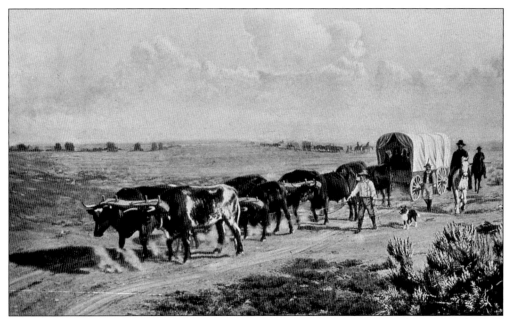

WESTWARD EMIGRATION. The largest peacetime human migration in US history took place between 1840 and 1870. In 1854, Roop's store register in Susanville reported that 23,000 people came that summer, crossing on the Nobles Trail with 68,000 head of cattle and 12, 000 horses. Prior to 1862, about 10 percent of the people on the trains were slaves. (From Coy's *Pictorial History of California*, courtesy of University of California, U.C. Berkeley Extension.)

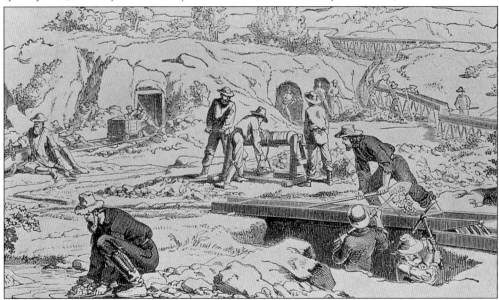

THE CALIFORNIA GOLD RUSH OF 1849. More than 300,000 people came West after the discovery of gold at Sutter's sawmill in Coloma, California. John Bidwell found wealth prospecting for gold in the Feather River. He described those seeking gold alongside him, "The Yankee, the Mexican, the Spaniard, Portuguese, Chinese, Malay, New Zealanders, Sandwich Islands, Chillanians, Peruvians, besides various tribes of Indians, tame and wild." (From Coy's *Pictorial History of California*, courtesy of University of California, U.C. Berkeley Extension.)

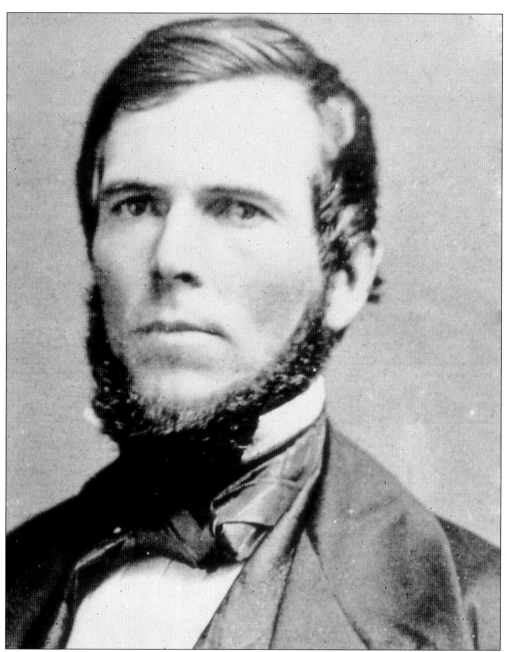

JOHN BIDWELL, 1858. By age 39, John Bidwell had traveled most of California by horse and on foot, became wealthy during the gold rush, owned a prosperous ranch, and planned to start a new city. When miners struck gold in Nevada, and later in Idaho, the idea of a trans-mountain road to these places of wealth and new markets seemed a good investment risk. He knew the terrain, had the fortune and good reputation to attract other investors, and he had the land on which new businesses could build. He surveyed the route of the Humboldt Wagon Road, raised money, supervised its construction, and provided for its maintenance. What he did not bet on was the future of transportation going to the railroads. Nevertheless, the Humboldt Road remains a living legacy. (Courtesy of John Nopel collection.)

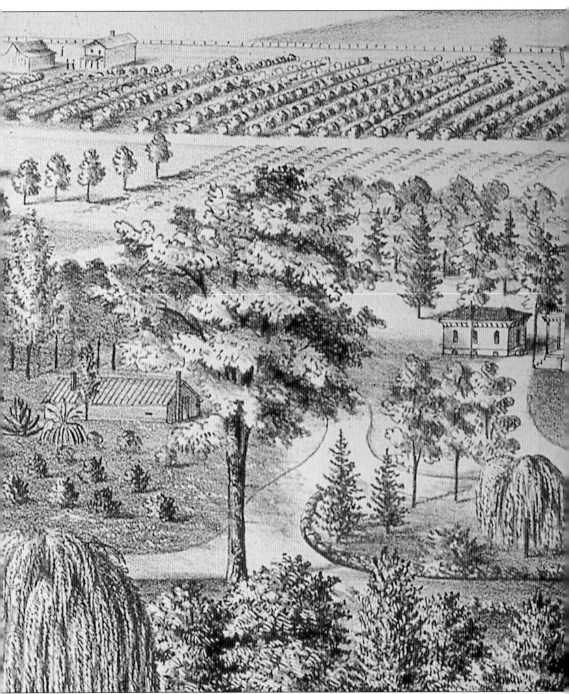

RANCHO CHICO. This 1877 lithograph from Smith & Elliott's book, *Butte County Illustrations*, shows the extensive development of John Bidwell's ranch and his agricultural success. The Bidwell Mansion at the center was completed in 1868, the year Bidwell married Annie Kennedy. Bidwell's primary ambition was to be a successful farmer. The rancho was a microcosm of California agricultural production where Bidwell kept domestic livestock and grew wheat, fruit, nuts, grapes, and vegetables. Attracting an adequate labor force for an operation this size was a problem at

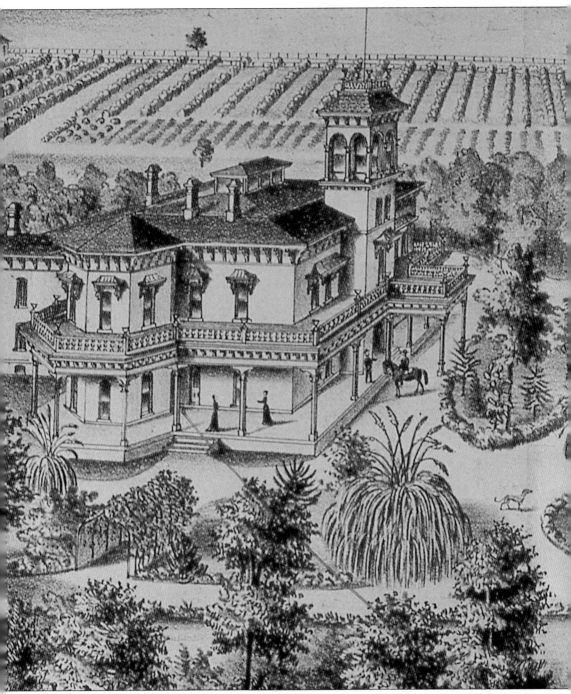

first. Bidwell recruited Indians, Chinese, and newcomers to the area. He and a partner operated a lumber mill in Chico Meadows as early as 1859. By 1860, following Indian trails that had long used a ridge top route as far as Big Meadows and beyond for travel and trade, Bidwell began to improve these trails into a wagon road. The rancho's diverse operations generated Bidwell's primary personal income and helped him sustain his lifelong financial and personal interest in the Humboldt Wagon Road. (Smith & Elliott *Butte County Illustrations*, 1877.)

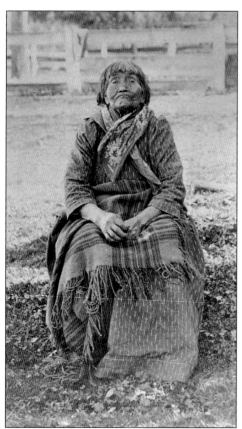

LADY MARY PULLISA. Most Maidu adapted to the huge influx of new settlers; some resisted. Racial tensions exploded. In 1863, Butte county Indians were expelled and forced to endure the infamous two-week Nome Cult Walk. Of the 461 Indians who began, only 277 reached their destination, a coastal reservation. Soldiers murdered some Indians en-route. Some, including Lady Mary, survived, and eventually returned to Chico. Many lived at the Rancheria on Bidwell's Rancho, forced to trade protection for a significant loss of tribal culture. (Courtesy California State University, Chico, Meriam Library, Special Collections.)

MECHOOPDA INDIAN ROUNDHOUSE. The Mechoopda Rancheria, on the Bidwell Rancho, was called *Bahapki* or "unsifted" by the Maidu because so many different Indian tribes were represented there, not just Mechoopda. Bidwell's account ledgers recorded payments to the Indians that included clothing, food, and compensation on par for non-Indian workers doing the same work. After work, Indian men relaxed in the traditional roundhouse where they gambled, performed dances or spiritual practices, and passed on the culture to the boys. (Courtesy of John Nopel collection.)

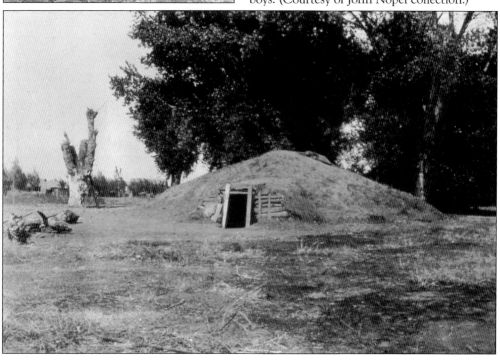

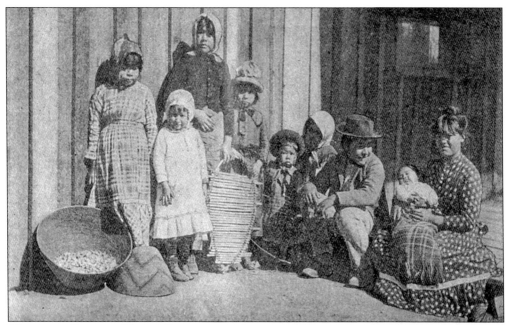

MECHOOPDA INDIANS. The pre-European population of California Native Americans was estimated to be about 300,000. By 1870, when the Humboldt Road was in steady use, the population had fallen 90 percent to a shockingly low 30,000 individuals. Both the Valley and Mountain Maidu tried to bridge the cultural gaps caused by this decimation. This family wore Western dress and used Indian baskets for food and the traditional cradleboard in the center. (Courtesy of John Nopel collection.)

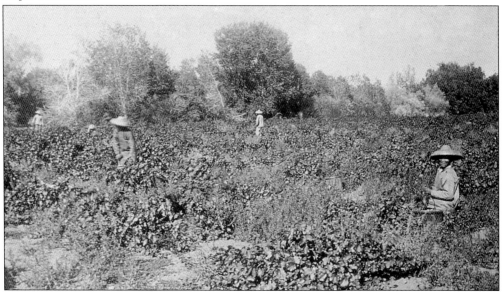

CHINESE WORKING IN BIDWELL VINEYARDS. Chinese immigrants helped fill a ready labor market. In 1863, Bidwell noted payment for work on the road to six Chinese men. In 1867, when the Chico to Idaho section of the road was built, a work force of 100 Chinese was recruited. Later, the Chinese suffered terrible racial persecution over competition for jobs. (Courtesy of John Nopel collection.)

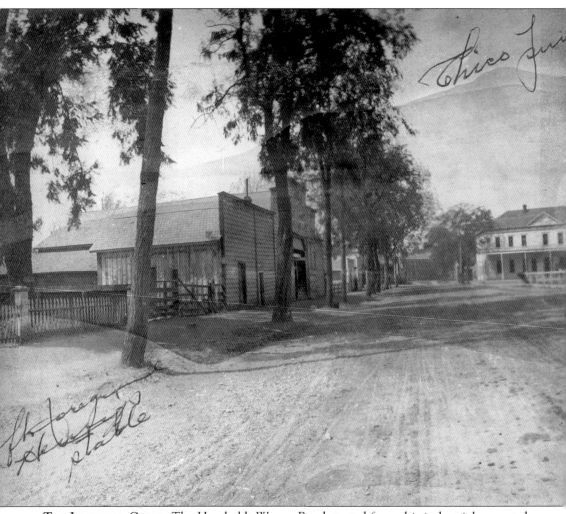

THE JUNCTION, CHICO. The Humboldt Wagon Road started from this industrial area at the southern end of downtown Chico, heading east toward the foothills. Businesses in this part of town supplied much of the demand for freighting across the mountains. At the center of the photograph is the Chico Hotel. In the left foreground are the Henry Stables. This view faces

north. The broad expanse in the foreground was typical of town and city construction of the time. It allowed a turnaround for long strings of horse freight teams and saddle trains. In 1866, drivers broke wild horses for the Chico to Idaho stagecoach service on Chico streets and in the Junction turnaround. (Courtesy of Randy Taylor collection.)

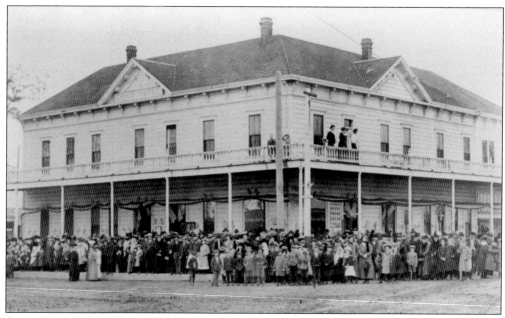

CHICO HOTEL, ABOUT 1910. The August 21, 1869, edition of the *Northern Enterprise* newspaper carried the following advertisement: "Junction Hotel, at junction of Main and Broadway, W. Combs, proprietor. The Junction Hotel is a newly built house . . . The beds are comfortable, the water is cool, always having on hand Ice." (Courtesy of California State University, Chico, Meriam Library, Special Collections.)

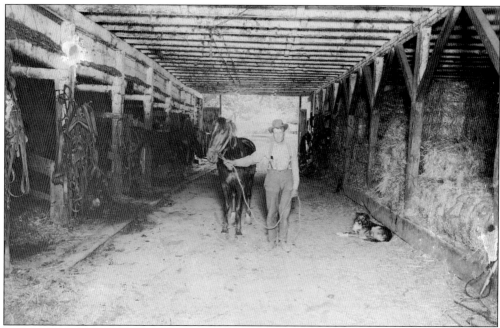

HENRY CORRAL. This business at the Junction was near Little Chico Creek Bridge and Dead Horse Slough. Horses were stabled there to rest between trips up and down the road. Dead horses and other livestock were thrown into the slough to decay and eventually wash away. (Courtesy of John Nopel collection.)

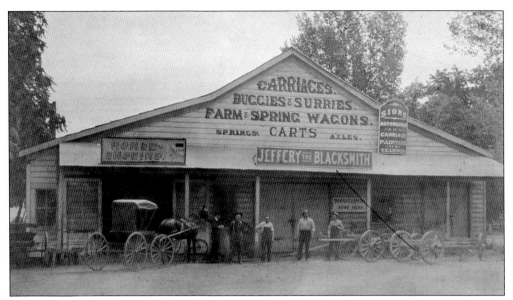

JEFFREY THE BLACKSMITH SHOP. Blacksmiths were essential to horse-powered transportation. Members of the Jeffrey family owned a city block for their business. The *Northern Enterprise* newspaper, August 21, 1869, carried the following advertisement touting services typical of a blacksmith operation: "Junction Wagon and Smithshop-N.H. Brouse. Wagons and carriages made to order. Best quality material and seasoned woods for carriages and wagon repairs. Blacksmithing-iron wagons and buggies, make plows and horse shoeing. Painting of wagons and carriages." (Courtesy of John Nopel collection.)

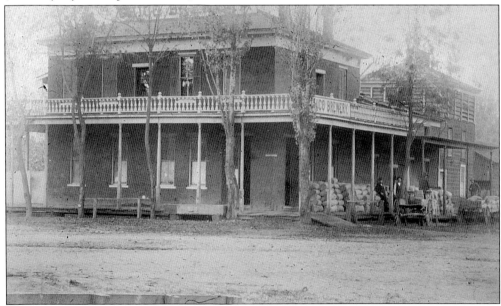

CHICO BREWERY. In 1874, for $1, Charles Croissant bought from John Bidwell the half block on which the brewery stands. He apparently tore the original building down and rebuilt it. He served beer there for 25 years. A saloon and card room occupied the front rooms on the ground floor. The upper floor functioned as a boardinghouse. The beer was brewed in the rear of the building. (Courtesy of John Nopel collection.)

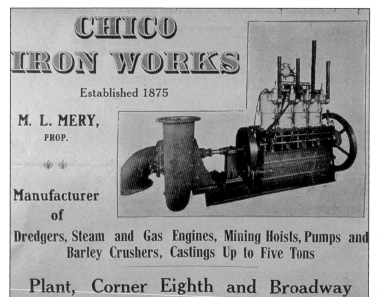

CHICO
IRON WORKS

Established 1875

M. L. MERY,
PROP.

❧ ❧

**Manufacturer
of**

Dredgers, Steam and Gas Engines, Mining Hoists, Pumps and Barley Crushers, Castings Up to Five Tons

Plant, Corner Eighth and Broadway

AD FROM CHICO PAPER. In 1870, Chico's population was 3,714. Most of what is known about commercial Chico at that time is from newspaper ads. That year, newspapers listed three hotels, four pharmacies, six general stores, three saddleries, three restaurants, two furniture stores, two lumberyards, six churches, a school, a toy store, a brewery, and 16 saloons. (Courtesy of John Nopel collection.)

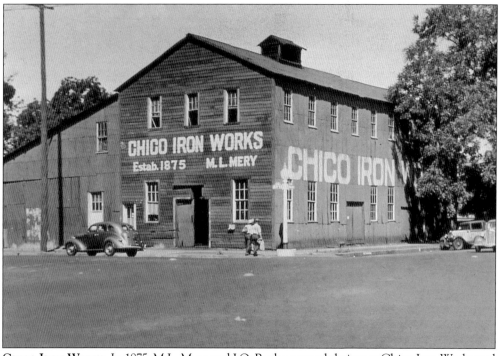

CHICO IRON WORKS. In 1875, M.L. Mery and J.O. Rusky opened their new Chico Iron Works and foundry. Their original structure suffered a devastating fire in 1885. Mery soon rebuilt a larger, more updated shop at the same address. (Courtesy of John Nopel collection.)

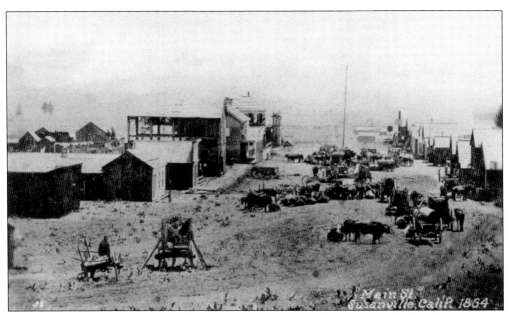

MAIN STREET SUSANVILLE, 1864. This is the earliest known photograph of Susanville, the initial destination Bidwell planned for the road. The view looks east. Susanville's strategic location as a gateway between Nevada and California is symbolized in the background. The Nobles Trail, the Humboldt and Humbug Roads, and the Tehama County Wagon Road (later called the Red Bluff-Susanville Road), all converge here and curve away to the left foreground of the picture, heading up the hill behind the town. (Courtesy of Plumas County Museum.)

PERSHBACKER MINE. Pershbacker Mine was located near Paradise on Little Butte Creek. It employed about 50 men. Buck Roney, grandfather of George and Elwin Roney, sits on the stump. Johnny Johnson, grandfather of Emma and Emily Uhl Roney, owned property in Forest Ranch. He is shown with his hands in his pockets in the back row to the left of Buck Roney. (Courtesy of George and Emma Roney collection.)

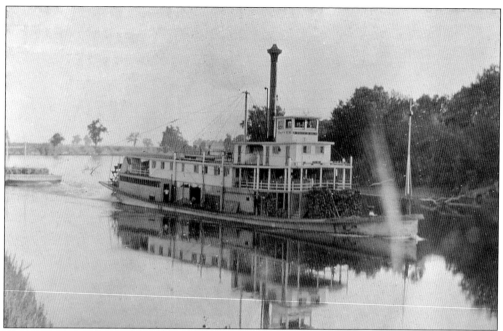

THE STEAMBOAT DOVER. Freight and people crowded San Francisco harbor and then dispersed, often up the Sacramento, San Joaquin, and Feather Rivers, to established landings. The *Dover* worked the upper Sacramento River, coming to landings west of Chico. (Courtesy of John Nopel collection.)

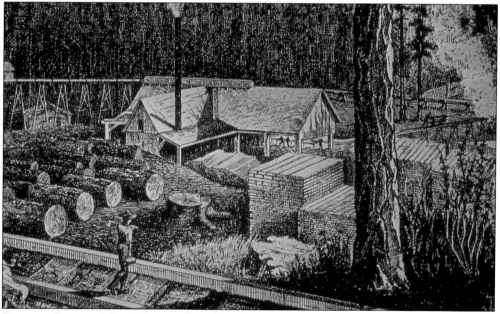

BELMONT LUMBER MILL. This small, independent mill was located on Cascade Creek, above today's Soda Springs. By 1860, steam-powered lumber mills dotted Butte County's mountains. In the several decades following, corporate consolidation and steam-powered saws, locomotives, and tractors brought a machine-age revolution to the harvesting and processing of California's forest trees. (Courtesy of John Nopel collection.)

26

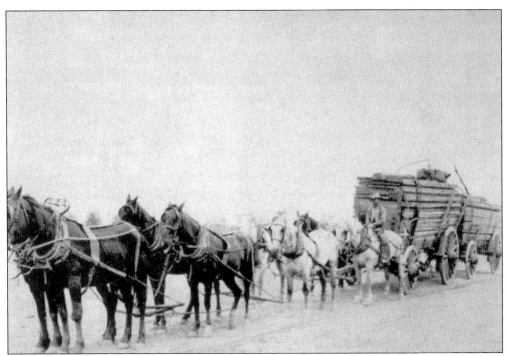

FREIGHTING. During the first 20 years of large-scale timber harvesting in California's Sierra-Cascade Mountains, moving cut lumber from the sawmills down to markets was difficult and expensive. This picture shows a load of lumber coming into Chico along the Humboldt Road. (Courtesy of John Nopel collection.)

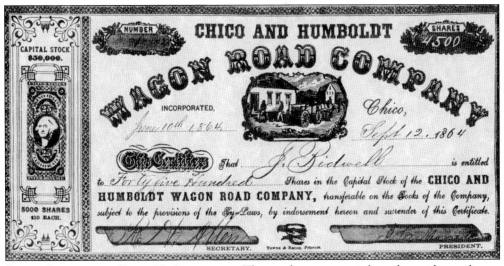

STOCK CERTIFICATE, CHICO TO SUSANVILLE. The need to move people and provide supplies to mining operations in Nevada and Idaho spurred road expansion throughout California. In the early 1860s, to raise money to build the Humboldt Wagon Road, Bidwell and his partners issued stock certificates for sale to help raise capital of $40,000. California roads were locally built and maintained until the 20th century. (Courtesy of John Nopel collection.)

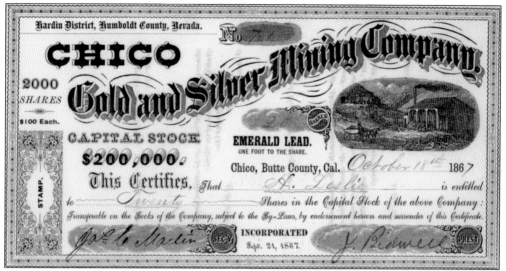

FROM SUSANVILLE TO IDAHO. On March 24, 1866, the *Chico Courant* reported that a stage company formed by stockbrokers in New York and Baltimore invested $300,000 to open mail and stage service between Chico and the Boise Basin. Gold strikes in Idaho attracted national investors to a trans-Sierra road to the mines. (Courtesy of Randy Taylor collection.)

CHARGING TOLLS. There was a tollgate about 15 miles from Chico, just before Forest Ranch, and another at Ruffa Ranch. At one time, the toll was 1¢ per person and 2¢ per animal to pass. Native Sons of the Golden West erected this sign. The sign has been replaced by a plaque, donated by the Native Daughters of the Golden West, located in front of The Store at Forest Ranch. (Courtesy of *Chico News & Review.*)

Two

RIDING THE OLD
HUMBOLDT WAGON ROAD

WHAT AN EXPERIENCE! Fern Stephens, whose parents operated two hotels along the Humboldt Road, watched horses pulling freight wagons past them in the early 1900s. "It was almost all horses. Don't remember many mules. Those horses were practically human," she said. It was a long pull of almost 100 miles between Chico and Susanville. This horse was on the Humboldt Road, passing through Ruffa Ranch, heading west toward Chico. (Courtesy of Dan Heal, from the Margaret Tartar gift collection.)

REMAINS OF OLD HOG SPRINGS. After leaving the Junction and Chico, the road ran east along Little Chico Creek, across the eastern edge of the Sacramento Valley, and began to climb up into the foothills. About six miles from Chico, at an elevation of about 800 feet, this was the first rest stop with available water. (Courtesy of John Nopel collection.)

ADA DODGE HULL. Ada Dodge's parents, James and Laura Smallwood Dodge, lived in Forest Ranch, up the road from Hog Springs. When the time came for Ada's birth, Laura went to Hog Springs where her sister Ellen and her husband, Ben Nugent, lived. Ada was born at Hog Springs. Ellen and Ben supplied food and water at the springs for horses and people traveling the road. (Courtesy of Otis and Shirlon Dodge collection.)

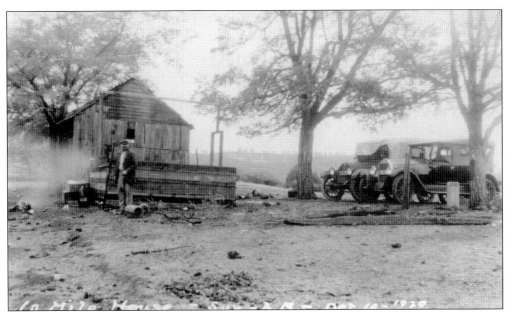

10-MILE HOUSE. Several miles upslope from Hog Springs was this stop, located 10 miles from Chico. Once the site of a house and two large barns, it often served as the first overnight stop for freighting teams. Water was hauled to the ridge top from springs and creeks in the canyon and sold for "10¢ a head for man or animal." (Courtesy of John Nopel collection.)

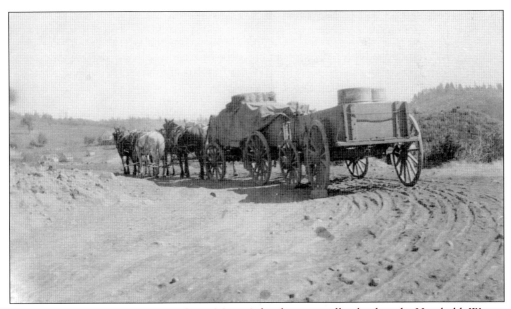

HEADING UP THE ROAD, C. 1900. Oscar Martin's freight team pulls a load up the Humboldt Wagon Road, heading east toward the 14-Mile House stage stop in the distance. Martin had freight offices in Chico and Chester. He and Peter Olsen, of Big Meadows pioneer families, named the town of Chester in 1900. Barbara Greene Maggi remembered the road was especially dusty between Chico and the 14-Mile House. (Courtesy of Beverly Benner Ogle collection; gift of Jim Davis.)

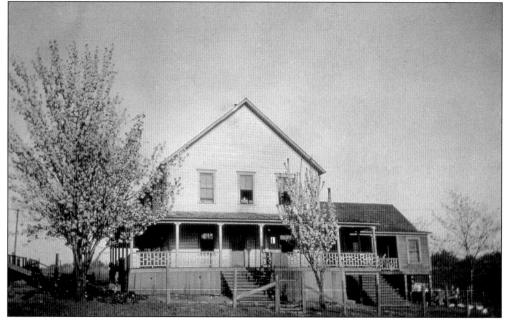

14-Mile House. Three prominent families succeeded one another in operating this site: the Spires of Vina, the Dorretts of Forest Ranch, and the Lucas family. Paul Lucas and Ellen O'Callahan met and married in Chico in 1865. In about 1894, John "Jack" Lucas, their oldest child, built this two-story building to replace an earlier hotel. (Courtesy of John Nopel collection.)

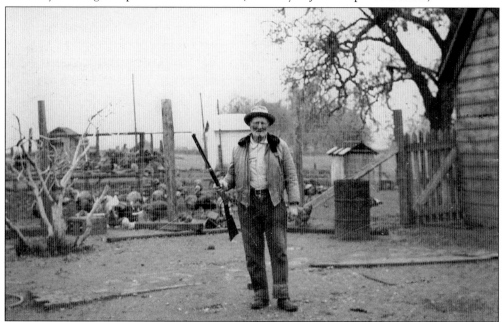

The Lucas Family. Paul and Ellen Lucas had a ranch of about 1,000 acres on both sides of the Humboldt Road. Paul died in 1880. Ellen persevered. With the help of her children, she kept the ranch going. Jack Lucas became a prominent Butte County cattleman. He is standing near the Humboldt Road where he established a slaughterhouse. He and wife, Helen May Wilson, from another Forest Ranch family, had 12 children. (Courtesy of Jack W. Lucas collection.)

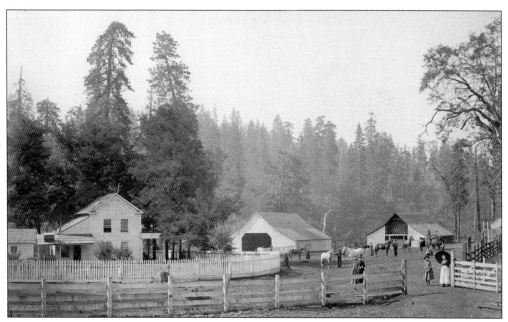

FOREST RANCH HOTEL AND ADJACENT BUILDINGS. About two miles above 14-Mile House, past the Humboldt Road tollgate, was Forest Ranch. Known earlier as the Findley Place or 16-Mile House, this site was located at an elevation of about 2,400 feet. The large two-story hotel and barns stood just south of present downtown Forest Ranch. (Courtesy of John Nopel collection.)

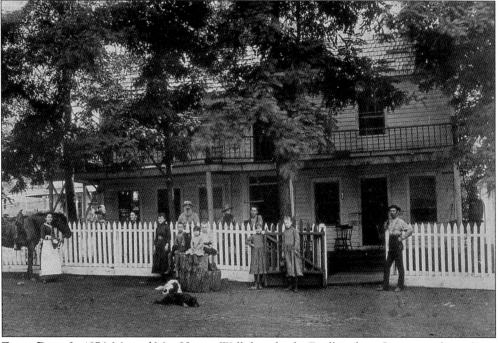

EARLY DAYS. In 1876, Mr. and Mrs. Horace Wells bought the Findley place. Some years later, Capt. John and Margaret Loftus Morrison bought the property. A post office and school district were established here in 1878. The name Forest Ranch was chosen to fill the postal name requirement. Horace Wells was the first postmaster. (Courtesy of John Nopel collection.)

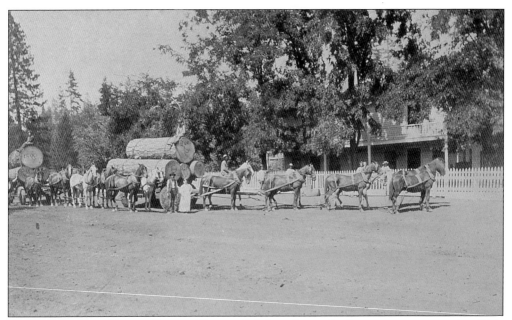

LOGGING TEAM AT FOREST RANCH HOTEL. California's conifer forests were spectacular. Rich volcanic soils, bountiful water, and a long growth season made the southern Cascade Mountains especially suitable for these trees. The lumber industry grew simultaneously with gold rush mining. Downed timber is hauled past the Forest Ranch Hotel on the way to Captain Morrison's nearby sawmill. (Courtesy of John Nopel collection.)

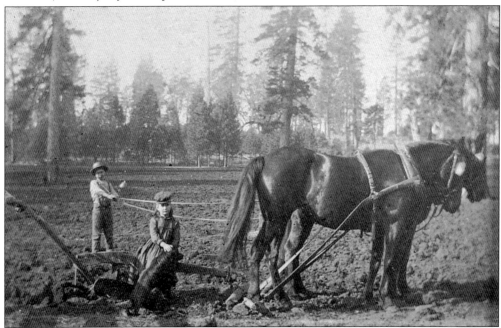

FOOTHILLS FARMING. Farm products became the enduring gold of California as mining claims played out. Along the Humboldt Wagon Road, as high as 5,000 feet elevation, gardens and orchards, like this one in Forest Ranch, accompanied the building of houses. The "work force" was the family. (Courtesy of John Nopel collection.)

JOHNNY JOHNSON. Johnny Johnson owned a place in Forest Ranch and drove a freight wagon over the road to Prattville. He originally bought the property in 1888 for $2,250. In 1894, he sold it to the Halley family. Johnson was the grandfather of Emma and Emily Uhl Roney of the ranching family featured in this book. (Courtesy of George and Emma Roney collection.)

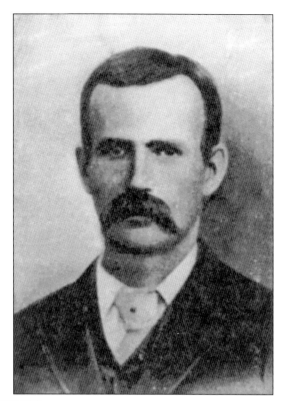

THE PRESLEY HALLEY FAMILY, C. 1888. Shown in this picture is Halley's second wife, Mary Jane Gray Halley, son Glenn, and daughter Nancy on Mary Jane's lap. Their Forest Ranch property had a house and a barn wide enough for three horse teams abreast to drive through. Though not an official stop on the road, the Halleys provided lodging for ranchers bringing cattle to mountain pastures from 1890s to 1940s. (Courtesy of Aileen Selvester collection.)

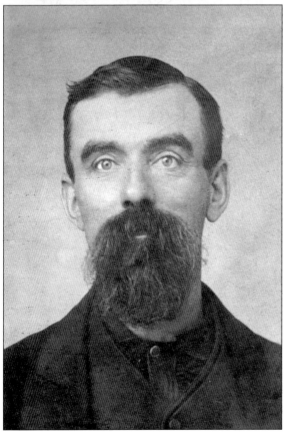

THE SHUFFLETON FAMILY, 1895.
By 1869, John Henry Shuffleton and wife, Margaret Ann Deaver Shuffleton, lived in Forest Ranch. They ran a hotel and local toll station, prompting some to call the Forest Ranch area "Shuffleton's." It soon became part of Forest Ranch. They planted the first commercial apple orchard on the ridge. They supported public education, giving land for the first four Forest Ranch schools. Their children were Annetta, Nellie, and Harry. (Courtesy of John Nopel collection.)

THE DORRETT FAMILY. Fred Dorrett first purchased property for $10 at West Branch. He sold that and bought the 10-Mile House, which he sold to John Hallenbeck, who also bought Hog Springs. Dorrett's next purchase was the 14-Mile House in 1884, which he then sold to Paul and Ellen Lucas. Dorrett served as toll collector and a justice of the peace for the area. (Courtesy of Sara King collection.)

THE WILSONS. After operating a dairy ranch in Ventura, James H. and Julia A (Goodelle) Wilson came to Forest Ranch in 1886 via New York, Illinois, and Missouri. James served in an Illinois regiment in the Civil War. They built and operated the Economy Store in Chico. In 1896, James bought 160 acres on Doe Mill Ridge near Forest Ranch. They had nine children, seven of whom lived. (Courtesy of Sara King collection.)

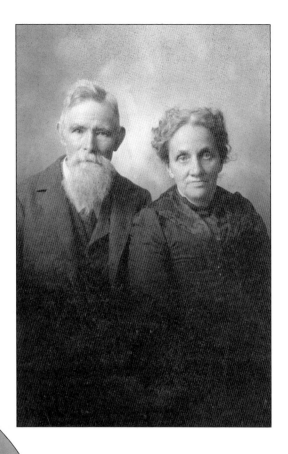

A MARRIAGE. Lizzie Wilson and William "Bill" Charles Dorrett's marriage united two Forest Ranch pioneering families. They bought her parents' homestead on Doe Mill Ridge, near Forest Ranch, and built a house there. The Shuffletons, Wilsons, Dodges, Dorretts, Berdans, Lucases, and Nopels inter-married with families from the other towns along the road and the ranchers who ran livestock on it. This formed an intricate network of relatives still in the area today. (Courtesy of Sara King collection.)

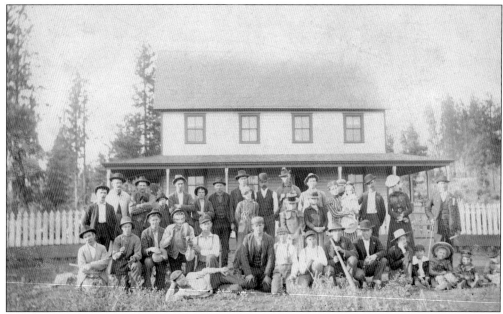

BASEBALL AT THE DORRETTS. Leona Taggart remembered, "Along about 1907, there was a baseball team organized at Forest Ranch and they had their ball field just in front of the Dorrett house where games were played most every Sunday . . . All our dances were held at Mr. Dorrett's house and most all parties, his being the largest place on the hill." Halleys and Dorretts are scattered among the otherwise unidentified people in this group. (Courtesy of Aileen Selvester collection.)

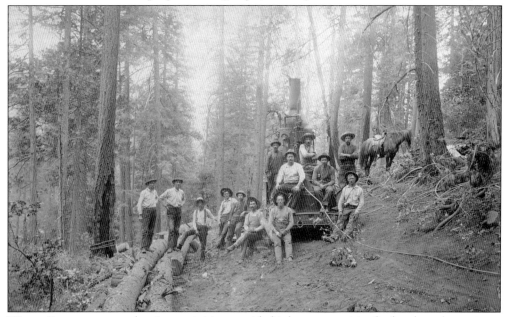

WORK. For many years, logging activities provided job opportunities for locals and transients alike. This 1902 photograph in the West Branch area shows a crew with a Dolbeer Steam Donkey engine. Ollie Dorrett, son of Fred and Bess Dorrett, is second from left. Note the logging chute, or skid, made of logs laid parallel through the forest. The Dolbeer would winch downed logs along the chute. (Courtesy of Sara King collection.)

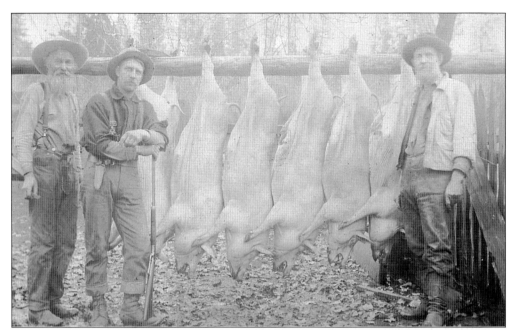

FOOD ON THE TABLE. From left to right, Mr. Willis, the younger Harry Shuffleton, and John Henry Shuffleton stand by butchered pigs. Sometimes, folks abandoned property, and with it their pigs. The pigs might run wild and would be hunted. The pigs were eaten, and grease from pigs, and even bears, was used to lubricate logging chutes. (Courtesy of John Nopel collection.)

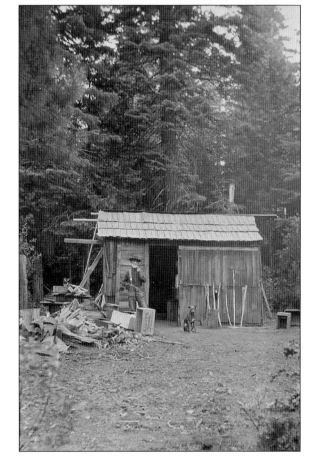

ROUGHING IT. Some people chose to live alone, often in simple, basic circumstances. Jim Garland, seen here at his cabin, was a miner, hunter, and hermit, who lived off the Humboldt Road. Today's Garland Road, above Forest Ranch, is named after him. (Courtesy of John Nopel collection.)

THE NOPEL FAMILY. Frederick Nopel was born in Bavaria, Germany, in 1836, and came to America in 1844 with his family. Following the end of the American Civil War, he married Augusta Neibauer in Illinois. Their eight children were born there. Because of Frederick's declining health, the family moved to Oakland, California, about 1880. (Courtesy of John Nopel collection.)

MAKING A HOME. California doctors recommended Frederick Nopel move to a moderate mountain climate. In 1889, the family purchased 84 acres in Forest Ranch from the Central Pacific Railroad for $253. The acreage was somewhat south of the present Nopel Avenue and Highway 32. The family built this cabin. Unfortunately, Frederick died in 1890. Members of the family resided in Forest Ranch over the following 80 years. (Courtesy of John Nopel collection.)

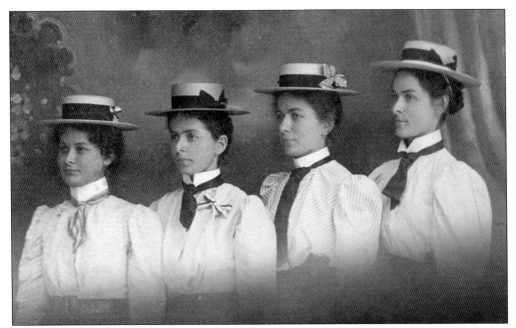

THE NOPEL GIRLS. The four daughters of Frederick and Augusta Nopel were photographed in about 1900. From the left are Lucy Margaret, Anna, Mary June, and Alice. They all married and spent most of their adult lives in Forest Ranch. Alice owned the original Nopel cabin property. Lucy served as Forest Ranch postmistress. (Courtesy of John Nopel collection.)

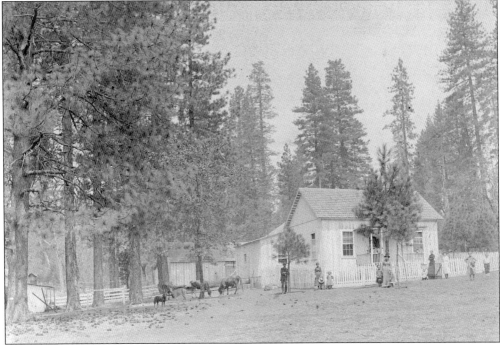

IT TOOK ALL KINDS. A.B. Collins was the first supervisor for the large and famous Llano Seco (Dry Plains) Mexican Land Grant ranch. Collins left the ranch for health reasons and built this home in Forest Ranch for himself and his family. (Courtesy of John Nopel collection.)

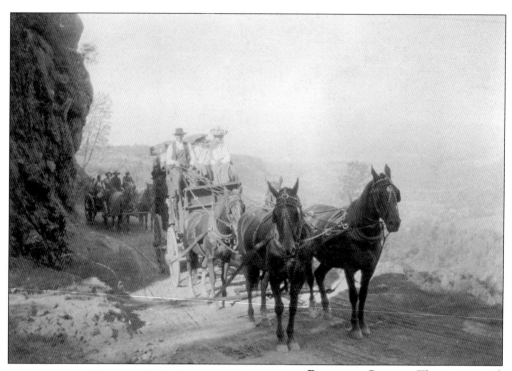

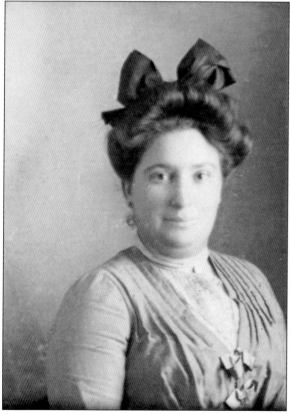

PASSENGER SERVICE. The wagon road did not necessarily go in a straight line. In flat places, which were often watering and food stops, drivers would travel a wide swath. They had to avoid sinking in wet places and to move aside when meeting oncoming traffic, often choosing a path depending on the condition of the road. Clara Lucas sits on the right in the front seat of the coach. Chico Creek Canyon can be seen below. (Courtesy of John Nopel collection.)

SCHOOLTEACHER. Clara Hicks was the oldest child of Daniel and Mary Signor Hicks. The parents of both Daniel and Mary had come overland to California in 1857 and 1859, respectively. Clara was a graduate of the State Normal School in Chico. A schoolteacher in Forest Ranch, she married George Lucas, son of Paul and Ellen Lucas. Clara and George worked in the Lucas livestock business. (Courtesy of Jack W. Lucas collection.)

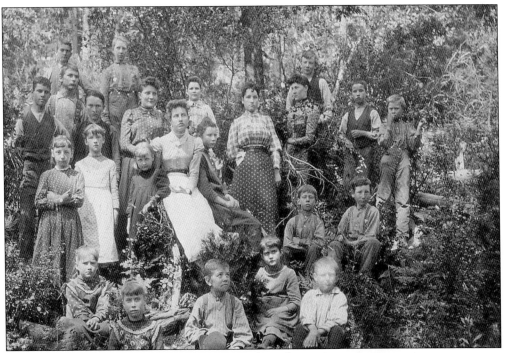

PICNIC. On May 4, 1889, an unnamed Forest Ranch resident wrote to the Chico *Enterprise* newspaper describing a community picnic. There were duets; a glee club sang songs, including "Picnic Glee" and "Tis May Day Morn." A May Queen was crowned and there were skits and a dance around the maypole. Lunch was spread on long tables, enough for 75 people. Dancing ensued, and guests did not leave until dawn the next day. (Courtesy of John Nopel collection.)

THE DODGE FAMILY. James and Emily Smallwood Dodge settled in Forest Ranch in the late 1800s. They had nine children and also sold produce and apples. His Black Twig apples took first place at the state fair. James had contracts to maintain the Humboldt Wagon Road from Hog Springs to the Summit. (Courtesy of Otis and Shirlon Dodge collection.)

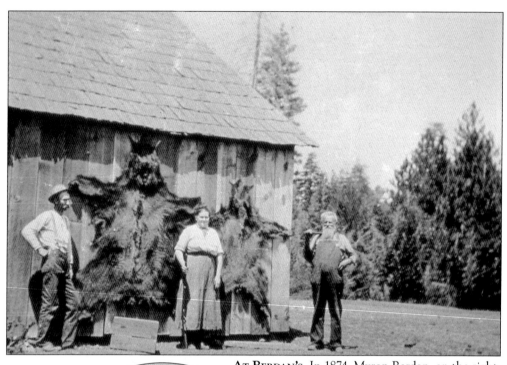

AT BERDAN'S. In 1874, Myron Berdan, on the right, purchased land along the Humboldt Road, four miles above Forest Ranch. He had a post office and developed a popular stopping place for travelers and teamsters. Myron tallied 14 bears, two mountain lions, and many deer from his hunts. He claimed he had the largest pair of deer antlers in Butte County. (Courtesy of John Nopel collection.)

LYDIA BERDAN. Daughter of Daniel Berdan, she was also the mother of James Dodge. Leaving James with his father, Perry Benjamin Dodge, she came to Red Bluff, California, with her brother Myron Berdan. Later, Perry Benjamin, his son James, and James's grandfather Daniel Berdan followed Lydia and Myron to California. All of them eventually lived in Forest Ranch. (Courtesy of Otis and Shirlon Dodge collection.)

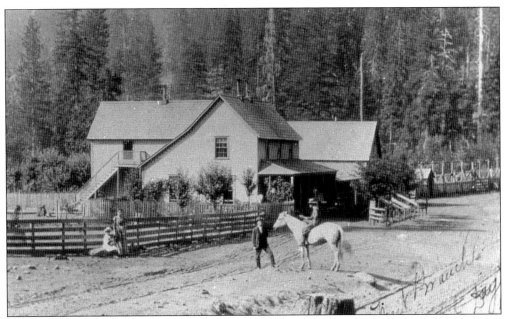

WEST BRANCH. Probably named for the West Branch of Butte Creek, about two miles away, this stagecoach stop provided bountiful spring water. It became a center for supply and logging operations between Forest Ranch and Butte Meadows. The West Branch hotel, pictured here, offered sitting porches, large barns, a saloon, and an outdoor dance pavilion. (Courtesy of John Nopel collection.)

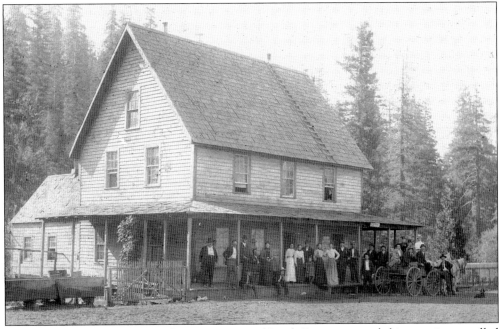

LOMO HOTEL, ABOUT 1903. When a man named Jacob Sprague owned this stop, it was called Hogs Back, which is English for the Spanish name Lomo. It was 30 miles from Chico. The location falls sharply on one side to the West Branch of Butte Creek and to Chico Creek on the other side. (Courtesy of California State University, Chico, Meriam Library, Special Collections.)

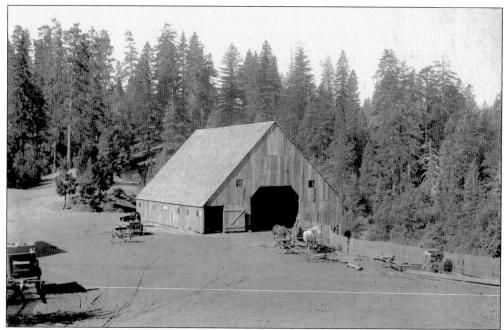

LOMO STAGE STOP. Owning and working with livestock required large barns, especially for the teams of many horses that pulled freight over the Humboldt Road. Barns, such as the one pictured, are fading from today's landscapes. The town of Lomo no longer exists. (Courtesy of the California State University, Chico, Meriam Library, Special Collections.)

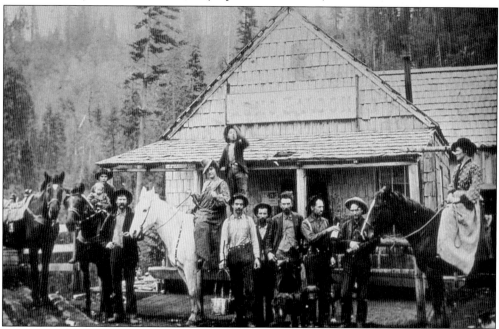

"HAPPY HOUR," LOMO SALOON. In the early 1940s, Florence Danforth Boyle, a newspaper columnist for the *Oroville Mercury Register*, wrote about Butte County history. She located an 1880 "register" that listed 57 men living in Lomo. Their occupations included hotel operators, a stage driver, a blacksmith, lumbermen, boilermakers, and engineers. (Courtesy of John Nopel collection.)

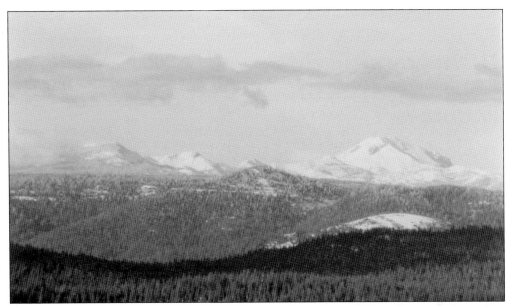

LASSEN PEAK. Early emigrants on the Lassen and Nobles Trails used this still-active volcano (the mountain seen at the right) as a landmark to help guide them to the end of their long, cross-country journeys. It last erupted between 1914–1917. This view looks north from the Humboldt Road near Butte Meadows. It was and is a familiar sight to anyone traveling between Chico and Susanville. (Courtesy of Anita Chang collection.)

POSTCARD VIEW. From Lomo at 3,800 feet, the Humboldt Wagon Road climbed steadily uphill for two miles until it reached the "Little Summit" at 4,500 feet. This was one of the most challenging grades on the road. Sometimes passengers got out and walked to help the horses pull the load. From the summit, the road dropped downhill and entered the relatively flat, fertile Butte Meadows area at an elevation of 4,300 feet. (Courtesy of Anna Marks collection.)

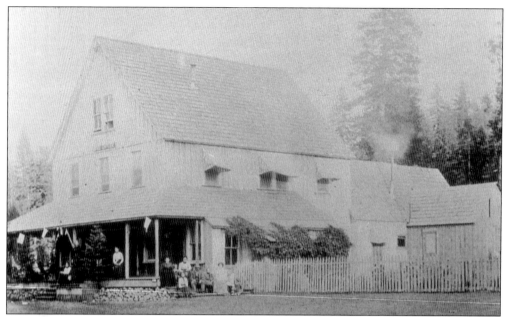

ENTLER HOTEL. There was a string of hotel buildings in Butte Meadows, beginning with James McGann's first structure in the 1860s, built with wooden pegs instead of nails. Apparently, five successive hotel buildings occupied the site immediately west of today's Bambi Inn on the south side of the road. All hotels were destroyed by fire. The third building, the Entler Hotel, is shown. (Courtesy of John Nopel collection.)

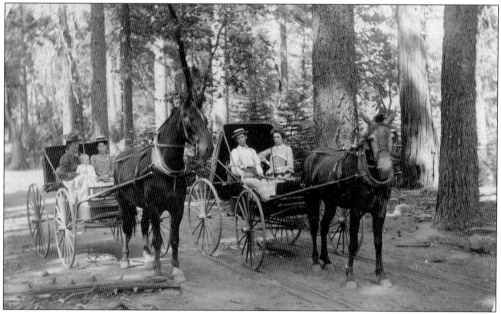

GOOD HORSES EQUAL SHORT MILES. These buggy drivers on the road at Butte Meadows are identified as "probably members of the Lucas family." The family leased horses to vacationers visiting in the summer. Rarely mentioned in history books, horses were essential to all that made the Humboldt Road a success. (Courtesy of California State University, Chico, Meriam Library, Special Collections.)

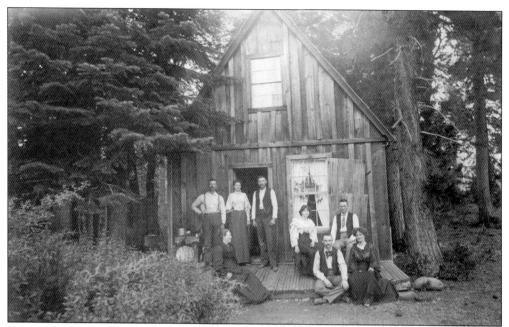

BUTTE MEADOWS. After the death of her husband, Paul, in 1880, Ellen, "Grandma" Lucas continued to operate and expand the family holdings. She and her older children purchased land in the Butte Meadows area for summer pasture for their cattle. The family built this cabin close to Butte Creek for summer use. (Courtesy of California State University, Chico, Meriam Library, Special Collections.)

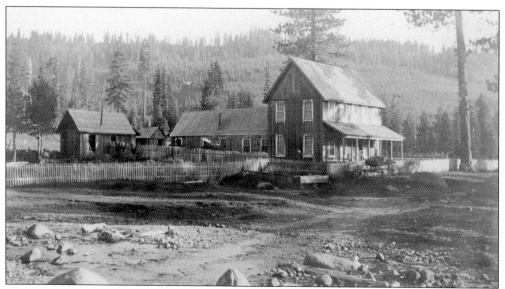

JONESVILLE HOTEL, AUGUST 1909. When Bidwell and his partners developed the road, they constructed barns and houses to sell or lease to individual operators. Situated about six miles above Butte Meadows and eight miles from the next stop over the summit at Ruffa's Summit Hotel, the Jonesville Hotel has been a landmark for travelers since 1869. (Courtesy of Anna Marks collection.)

BUSINESS WAS GOOD. From 1906 to 1919, Cass and Nick Stephens ran the Jonesville Hotel. Their daughter, seen here, was Fern. The road in front of the hotel was always busy with freight wagons and passenger traffic. Fern even had an organ delivered to her so she could practice her music lessons. Guests from Chico and as far away as San Francisco came to enjoy the temperate summer climate, abundant fishing, and good hunting. (Courtesy of Anna Marks collection.)

TIMOTHY HAY. For those who braved living year round at the higher elevations on the road, it was essential to lay in enough food for people, pets, and livestock. Timothy hay grew especially well at high altitudes. It survived snow and was nutritious for horses and cattle. The harvested hay was kept in the Jonesville barn. (Courtesy of Barbara Greene Maggi collection.)

MILKING TIME. Various dairy operations between Butte Meadows and Big Meadows produced milk, cream, butter, and wheels of cheese for sale. The self-sufficient families living in these places raised eggs, meat, and garden vegetables as well. A milk house stood at the east side of the Jonesville Hotel. Its walls were insulated with sawdust, and a stream running through the middle of the milk house kept perishable items cold. (Courtesy of Barbara Greene Maggi collection.)

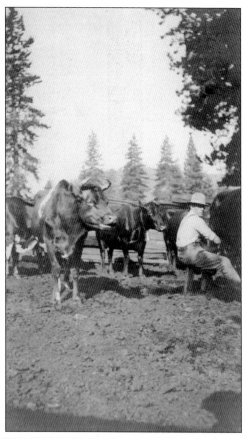

COLBY CORRAL. Thousands of animals were driven up and down the Humboldt Road. In the 1850s, stockmen began running large herds of cattle and sheep between the winter pastures in Sacramento Valley and summer pastures in the mountains. Generations of the Bennett-Roney families, from west and north of Chico, used part of the road in their ranching operations. Here, Roney cattle arrive at the Colby Corrals in 1967. (Courtesy of George and Emma Roney collection.)

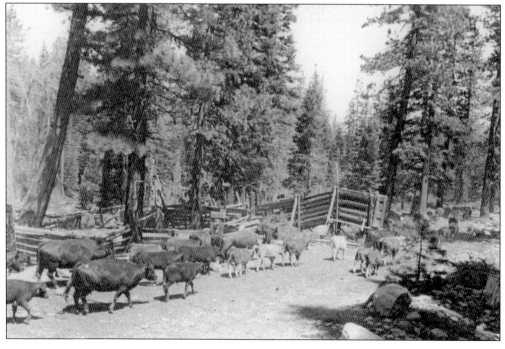

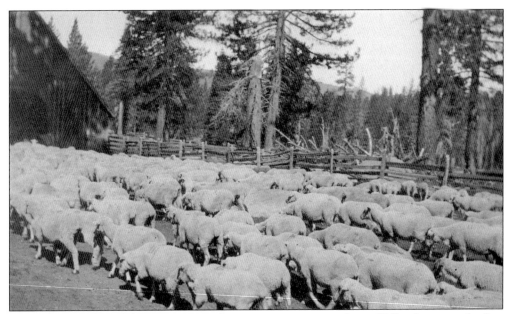

LIVESTOCK. Cattle and sheep were central to a growing economy. James T. Stephens was the first to have sheep in Butte County. His son Nick later operated the Jonesville Hotel. These sheep are moving past the Jonesville barn near the highest elevation of the road. (Courtesy of Barbara Greene Maggi collection.)

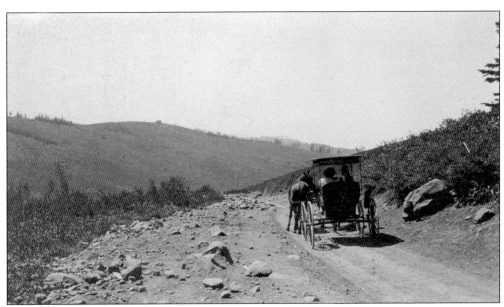

DAY TRIP. The Humboldt Road summit was more than 6,000 feet in elevation between Jonesville and the Summit Hotel. Drivers would attach a log behind their wagons to provide friction and slow the descent from the summit. Several people interviewed for this book reported their mothers made them walk coming up or down the steep slope for fear the stagecoach would go off the edge of the road. (Courtesy of Barbara Greene Maggi collection.)

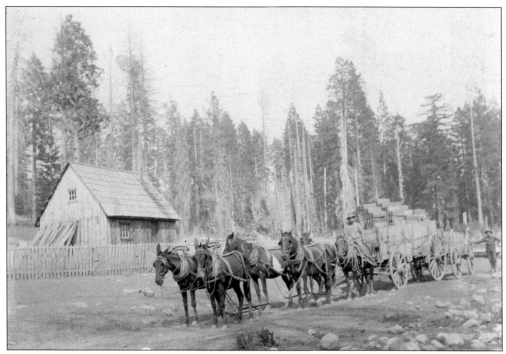

HAULING SHAKES. Some of the major products of the early lumber industry were shingles and shakes. They were used as roofing and siding for the new homes and businesses being built in a growing California. This load of shakes is being freighted west to Chico and across the lush valley of the Ruffa Ranch. (Courtesy of Dan Heal, from the Margaret Tartar gift collection.)

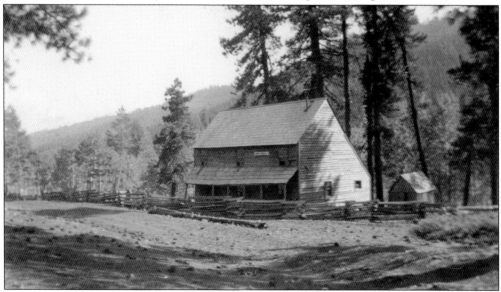

WELCOME SUPPLIES. Whether traveling 50 miles from Chico over the summit above Jonesville or coming 50 miles from Susanville over several high passes, travelers would be ready to rest and eat at the Summit Hotel. Dairymen Louie and Charlie Ruffa sold milk, butter, cheeses, and other items at the hotel. They sent butter and cheeses by stage to Chester, receiving payment for them on the return stage coach trip. (Courtesy of Dan Heal, from the Margaret Tartar gift collection.)

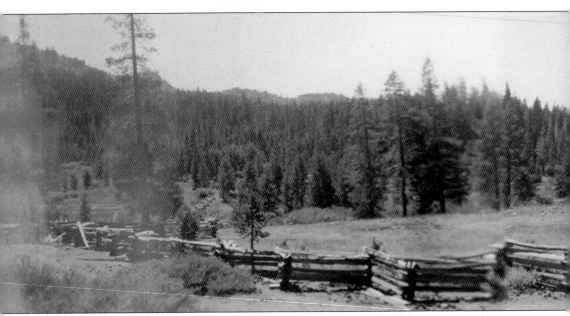

A Timeless View. This panorama, facing south, shows the Humboldt Wagon Road running through the Ruffa Ranch. A group of dairymen, who had once been neighbors in the Swiss Alps near the Italian border, settled in the valleys between Butte Meadows and Susanville starting in the 1850s. They carried on dairying and cattle ranching in these remote areas. Louis "Luigi" Ruffa first came to Plumas County, California, in the late 1800s. Persuaded to homestead some

land by fellow Swiss-Italian ranchers Baptiste and Victor Baccala and the Faniani family, Louis sent for his brother Charles. Working for $1 a day, they saved enough to buy their first cow and acquired 320 acres for two adjoining ranches here in the Butt Valley. This beautiful valley still looks much the same today. The largest stand of aspen trees in California gilds the valley views with gold in the fall. (Courtesy of Dan Heal, from the Margaret Tartar gift collection.)

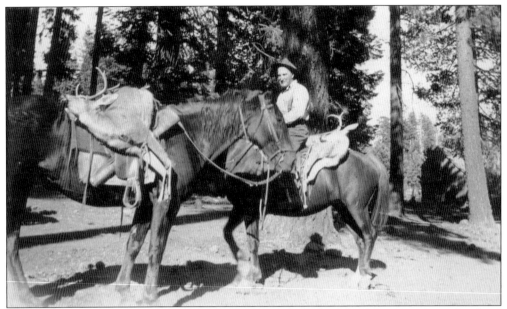

THE RUFFA BROTHERS. The brothers grew or hunted all their food, living independently at their remote ranch. When Charlie, pictured, announced he would marry Emma Baker of Vina, Louie expressed opposition, feeling the life the brothers had created would be too rough for a woman. Emma soon put that worry to rest. (Courtesy of Dan Heal, from the Margaret Tartar gift collection.)

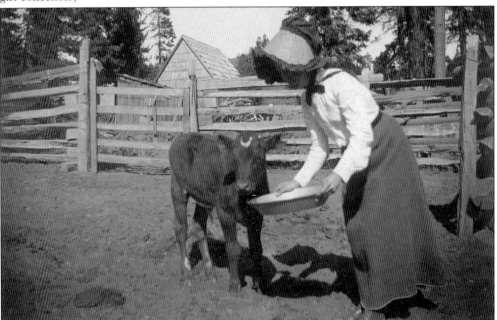

EMMA RUFFA. Emma Baker knew the daughters of the Faniani family, who ran the ranch next to the Ruffa brothers. After she and Charlie married, the couple ranched in Vina and Butt Valley. Emma also cooked for guests at the Summit Hotel. Louis, however, eventually returned to Switzerland. Charlie purchased Louie's portion of the ranch for $400. (Courtesy of Dan Heal, from the Margaret Tartar gift collection.)

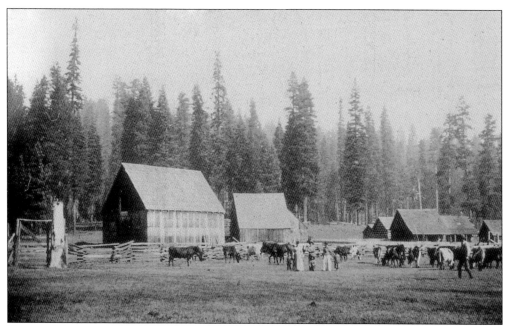

FANIANI MEADOWS. Faniani Meadows was between the Ruffa Ranch and Big Meadows. John and Martha Faniani built the ranch and dairy complex. Their oldest child, Della, died in a typhoid epidemic, which broke out in Chico in 1893. Some said that water wells in Chico were often too close to outhouses. (Courtesy of John Nopel collection.)

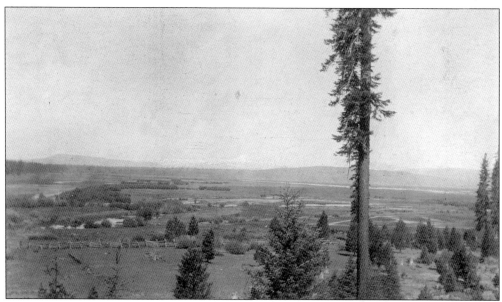

BIG MEADOWS. The Humboldt Road reached the western edge of the sprawling, beautiful Big Meadows at what became Prattville. The North Fork of the Feather River, one of California's largest rivers, drains off the southern slopes around Lassen Peak, which can be seen in the center distance. Big Meadows was 15 miles long and three miles wide. One early visitor described it as the following: "Green meadows, big trout." (Courtesy of Plumas County Museum.)

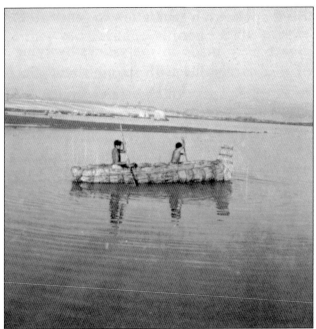

MOUNTAIN MAIDU LIFE. The Mountain Maidu were skilled at living in the wetlands of Big Meadows. They used canoes made from either reeds or rushes to get around. In the 1850s, Euro-Americans coming to Big Meadows put up fences, cut down timber, and built resorts for vacationers. The Mountain Maidu did not fight the forced changes so much as adapted to them by becoming laborers or homeless wanderers. (Courtesy of Naturegraph Publishers.)

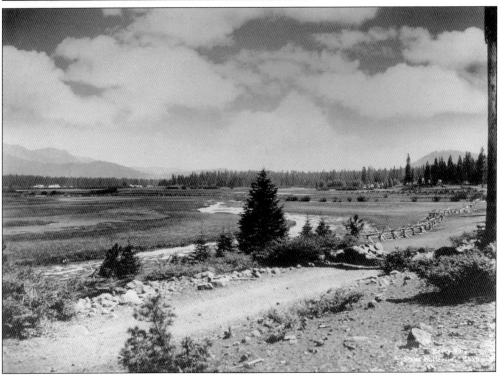

ROAD FROM PRATTVILLE TO CHESTER. The Humboldt Road in the foreground is skirting the western edge of Big Meadows and heading for today's Chester to the left. Buildings at Prattville can be seen about a mile away on the right with Bunnell's Resort on the far left. The photograph was taken by Maude Butterfield-Champion. Her family operated Butterfield's Resort, which is seen in the center in the distance. (Courtesy of Plumas County Museum.)

DR. WILLARD PRATT. Born in 1828 in Pennsylvania, Pratt became a physician. He arrived in California on horseback in 1853, with his medicines packed in saddlebags, and he treated patients in various mining towns. Eventually, he set up a practice in Chico. After his retirement, he bought 500 acres of land in Big Meadows and opened a resort. By the time of his death in 1888, about 2,000 tourists visited Big Meadows annually. (Courtesy of Plumas County Museum.)

FIRST PRATTTVILLE HOTEL. Built in 1867 by Doctor Pratt, this hotel burned in 1876 while the Pratt family members were at a national centennial celebration in Philadelphia, Pennsylvania. They rebuilt and opened a second hotel in 1877. On the right is the livery barn for the hotel. In the left background is the Prattville Springs branch of the Feather River. (Courtesy of Chester-Lake Almanor Museum.)

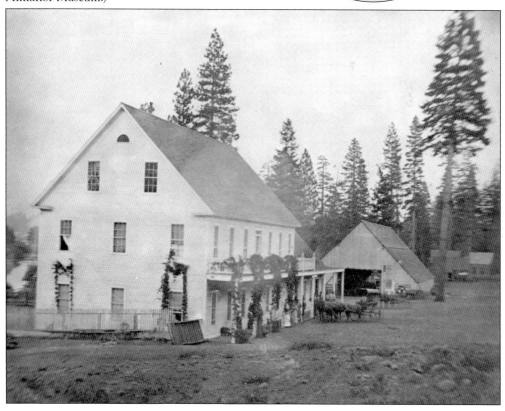

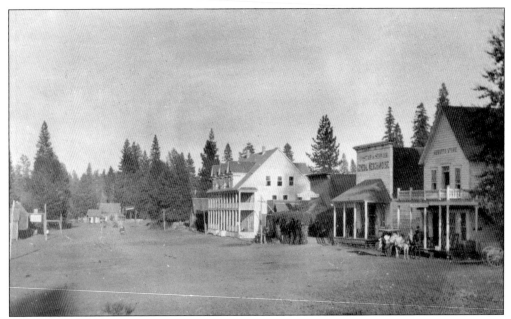

MAIN STREET PRATTVILLE, 1909. This scene is across the street from the Prattville Hotel. Starting in the right front of the photograph, is Abbott's Store. Next to it is the Stover-Costar Store, next is the vine-covered saloon, Sorsoli's, and beyond that is the Sorsoli Hotel, which was under construction at the time. The town burned July 4, 1909, just as the Sorsoli Hotel was reaching completion. (Courtesy of Chester-Lake Almanor Museum.)

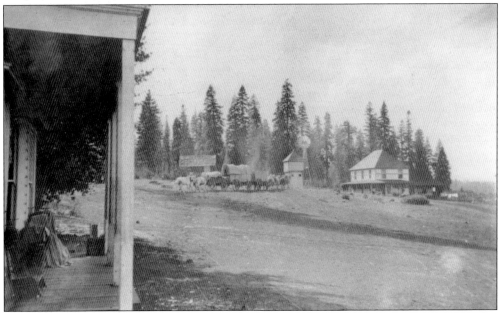

SUPPLIES TO PRATTVILLE. The porch posts at the left of this photograph are at the Stover-Costar store in Prattville, operated by Robert Costar and his wife, Josephine Stover Costar. After the 1909 Prattville fire, miners, ranchers, and workers for Great Western Power still worked in the area. Rob Costar's freight wagon is bringing in the supplies they needed. The center building is the Sorsoli Hotel. (Courtesy of Chester-Lake Almanor Museum.)

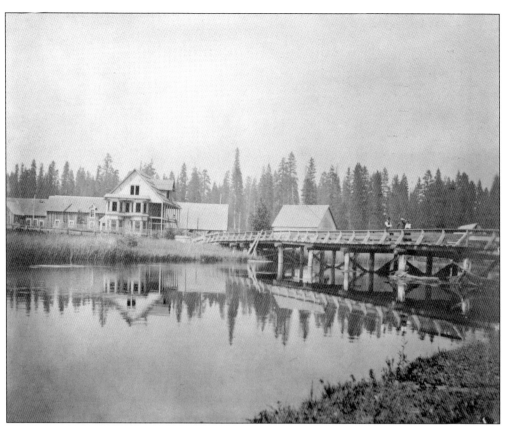

BUNNELL'S RESORT. The hotel was painted pale yellow with brown trim. The men's lounge had desks, round card tables, and prints of fish and game on the walls. Across the hall, the ladies parlor had lace curtains, easy chairs, and a piano. The hotel had two or three boats to use on the river. Bedrooms had the aroma of timothy hay that was cut and spread under the carpets. (Courtesy of Plumas County Museum.)

WILLAMINA "WILLY" PRATT SOMMER. A daughter of Doctor Pratt, Willamina "Willy" Pratt Sommer was a good friend of Annie Bidwell and the mother of Helen Gage. In 1873, she offered to guide some scientists around Lassen Volcano. She burned her foot in a boiling stream but continued the trip. A friend wrote years later that one of the scientists said, "She is as wild as that young horse she is riding, but extremely easy to look at." (Courtesy of John Nopel collection.)

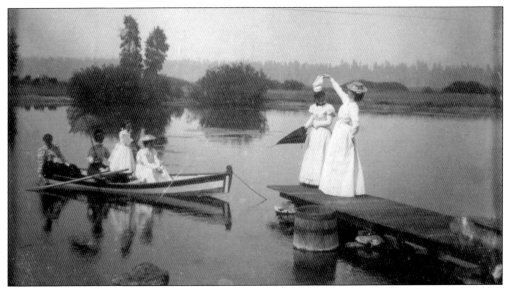

HELEN SOMMER GAGE. Helen is standing in the boat. Her cousins Genevieve and Hollis Pratt (from left to right) are on the dock. All three were granddaughters of Doctor Pratt. Helen remembered spending time in Prattville when younger, attending dances in the early 1900s. She said, "I was about the only girl my age for quite a ways around . . . everybody from . . . Greenville . . . the mines and . . . Chester . . . all came to the dances, so I had a really fine time." (Courtesy of Plumas County Museum.)

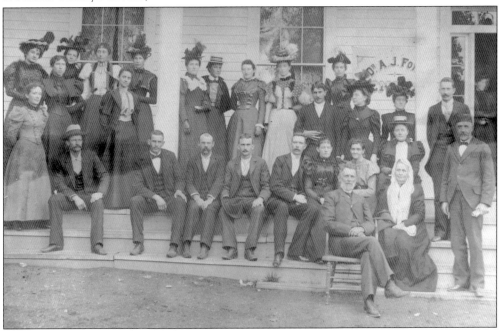

PRATTVILLE CITIZENS, 1890s. A gathering in front of the Prattville Hotel shows the formal dress worn even in the more isolated towns along the Humboldt Road. Freight and stage wagons using the Humboldt Road were stopping several times a week in Prattville. In 1880, the population of the Big Meadows Area was 535, of which 86 were Chinese and 137 were Indians. (Courtesy of Chester-Lake Almanor Museum.)

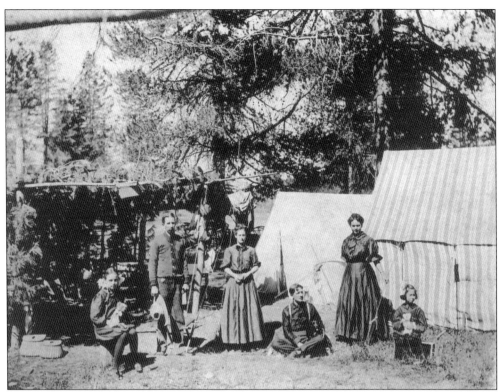

CAMPING AT BIG MEADOWS. The Walter Sharkey family of Oroville camped in front of the Olsen Hotel in 1905. Ranchers and farmers would take their families to Big Meadows to escape the valley heat. Women and children would camp for most of the summer, joined on weekends by the men. (Courtesy of Plumas County Museum.)

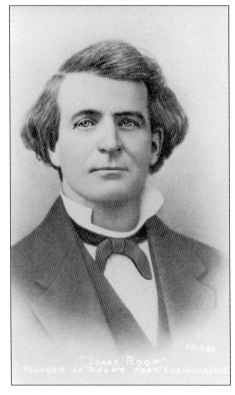

ISAAC ROOP. Susanville was next to the Honey Lake Valley, a major pass through the Sierra Nevada. Isaac Roop, credited with founding Susanville, hoped it would be a western commercial center as much as Bidwell hoped the same for Chico. Bidwell noted in his diary, "Honey Lake Valley is the key to the travel, trade and immigration from and into northern California." Roop named Susanville after his only daughter. (Courtesy of Plumas County Museum.)

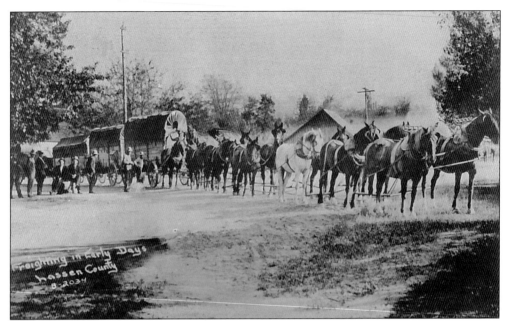

FREIGHTING TO SUSANVILLE. "Peddlers would come over the mountains from Chico with early fruit . . . They drove four or six horse teams with large wagons. They always had bells on the horses . . . anyone driving . . . upon hearing those bells, would draw off the road at the first spot wide enough for a team to pass," said Martha Buckhout of Susanville. Note the "Hanes bells" above the horses' heads in the photograph. (Courtesy of Lassen County Museum.)

SUSANVILLE, EARLY 1900S. About 1880, there was so much snow on the Humboldt Road that freight could not pass. A 52-inch diameter saw blade bound for Susanville was stored in a barn at Jonesville. The mill offered a reward for the blade. Marcus Gilbert, Blackie Gilbert's grandfather, took two packhorses to Ruffa's, snowshoed over the summit, got the blade, and returned to Susanville. He took the $150 reward but not the offered mill job. (Courtesy of Plumas County Museum.)

"CHICO TO SUSANVILLE." Bidwell and his partners raised $40,000 investment capital and built toll stations, rest stops, and places to get water along the road. Stage operations began in 1865. A major selling feature for passengers was the assurance that the road would be open all winter. Snow often made roads impassable, isolating Susanville and mountain communities for months at a time. (Courtesy of John Nopel collection.)

CHICO AND SUSANVILLE

STAGE LINE.

THROUGH FROM CHICO TO SUSAN-
VILLE IN THIRTY-SIX HOURS.

Stages leave Chico every Monday morn-
ing at 6 o'clock A.M.

Returning,

Leave Susanville every Thursday morn-
ing at 6 o'clock A.M., and arrive at
Chico in time to connect with the Sac-
ramento Stage, arriving at Marysville
the second, and at San Francisco the
third evening.

THIS ROUTE has been newly stocked,
and the trips will be made regularly.
We can and will make the trips in less
time than on any other route.

FARE $10.

Fast Freight, 6 cents per Pound.

☞ Arrangements have been made
to keep the ROAD OPEN ALL WINTER.
Chico, Nov. 11, 1865–tf.

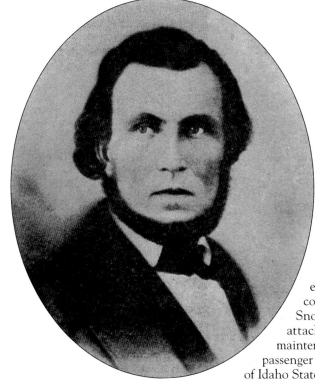

CAPT. E.D. PIERCE. In 1865, Pierce and J.B. Francis worked with John Bidwell to extend the Humboldt Road from Susanville to Ruby and Silver Cities. Bidwell provided much of the financial backing and equipment and helped secure a mail contract to make the line more lucrative. Snows impeded on-time mail, Indian attacks frightened passengers, and road maintenance was poor. Extended freight and passenger lines declined after 1867. (Courtesy of Idaho State Historical Society.)

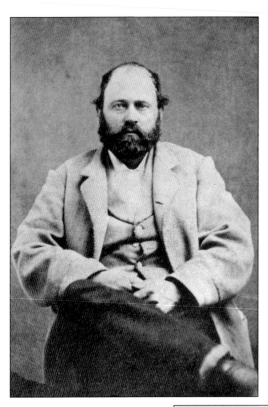

HILL BEACHY. Beachy attempted to establish a spur stage line off the Humboldt Road in Nevada. His attempt failed after two of his stages burned. In 1866, he succeeded in starting another stage line. It connected Idaho through Truckee, California, to the Central Pacific Train line that was completed in 1869. This line took less time and was cheaper than service on the Humboldt Wagon Road. It was Beachy's route that finally secured Idaho-California trade. (Courtesy of Idaho State Historical Society.)

EARLY SURVEY MAP. In 1865, Capt. John Mullen, who had established a reputation as a surveyor, engineer, and road builder in the west, traveled the Humboldt Road. He drew up this detailed map of the route from Chico to the Idaho mines. His "sketch" included distances between established towns and stage stops. (Courtesy of California State University, Chico, Meriam Library, Special Collections.)

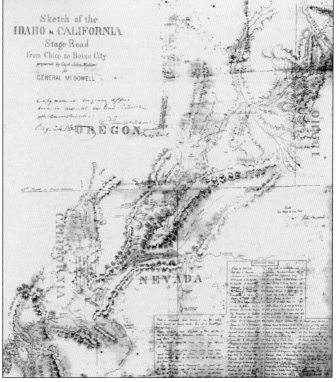

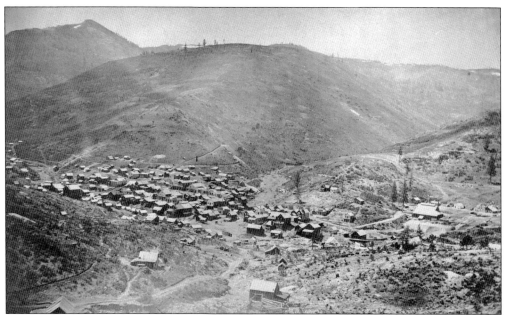

SILVER CITY. Although most accounts describe the terminus of the Chico-Idaho stage line as being Ruby City, Silver City was also a mining boomtown, located next door. In 1866, a tremendous gold and silver strike was made at Silver City, and the residents of Ruby City moved there practically overnight. The mining district of Silver City was second only to the Nevada Comstock Lode in production. (Courtesy of Idaho State Historical Society.)

ROADS THREATENED NATIVE PEOPLES. In Nevada and Idaho Territories, the Paiute initially fought to retain control of threatened food supplies, trade routes, and places to live. Indian attacks threatened demand for stage and freight services, but lust for gold overcame those fears. (From Coy's *Pictorial History of California*, courtesy of University of California, U.C. Berkeley Extension.)

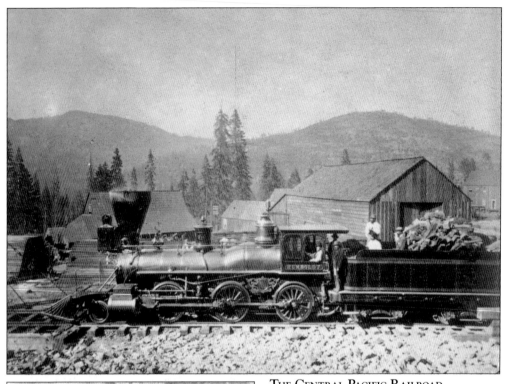

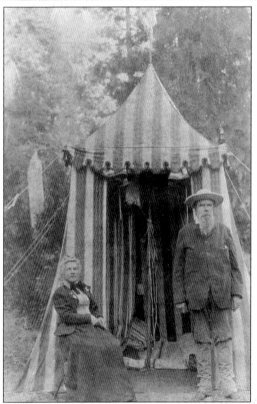

THE CENTRAL PACIFIC RAILROAD.
America's first transcontinental railroad was completed in 1869. In July 1870, the California & Oregon Railroad reached Chico. Over the next several decades, a railroad network developed that serviced the entire American West. Between 1868 and 1870, the vision for the Humboldt Wagon Road as a trans-mountain supply route faded. (Courtesy of Society of California Pioneers.)

ROAD MAINTENANCE. John and Annie Bidwell enjoyed the mountains. Throughout their marriage, they used this tent at their mountain camp near Chester, traveling, camping, and working on repairs up and down the Humboldt Road. Bidwell collected private subscriptions for maintenance of the road until his death in 1900 at the age of 80. He was clearing brush from a roadway on his ranch when he collapsed and soon thereafter died. (Courtesy of John Nopel collection.)

Three

COMMERCE RUNS THE ROAD

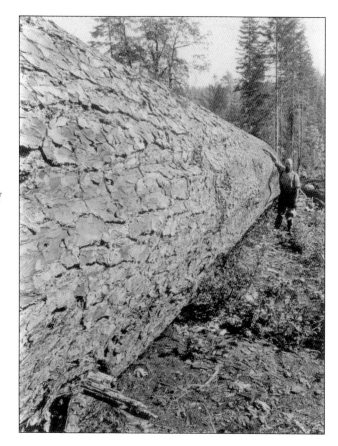

BUTTE COUNTY LUMBER INDUSTRY. The coming of the railroads opened the way to an international lumbering industry for the United States. Small, movable, independently owned lumber mills were scattered throughout the mountains, and use of the Humboldt Road facilitated the movement of people and goods. Butte County soon became the largest producer of pine wood products in California. This provided an industrial base for Chico that was stronger than that of other valley communities. (Courtesy of California State University, Chico, Meriam Library, Special Collections.)

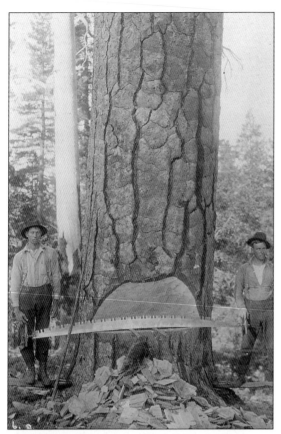

FALLERS. California's trees were enormous. The tallest, biggest, and oldest trees in the world grew here and still do. The coastal and inland California redwoods were central to early lumber operations. The Douglas fir and the sugar pine—North America's third- and fourth-largest trees—and the yellow or ponderosa pine shown here between two "fallers," were the primary commercial trees in the Sierra-Cascade forests. (Courtesy of John Nopel collection.)

A TRANSFER POINT. Moving cut logs from the forest to the mill was a herculean task. These two sketches from artist Will Taylor's portrayal of work in the woods illustrate the size of the mountain trees and the difficulties associated with cutting, moving, and milling them. (Courtesy of John Nopel collection.)

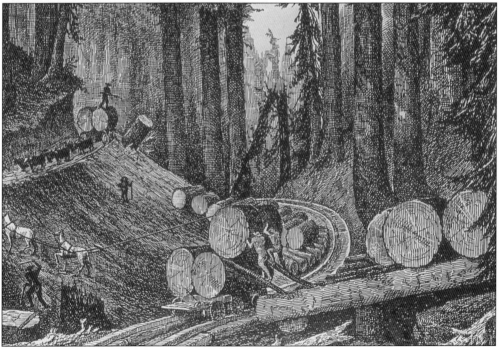

70

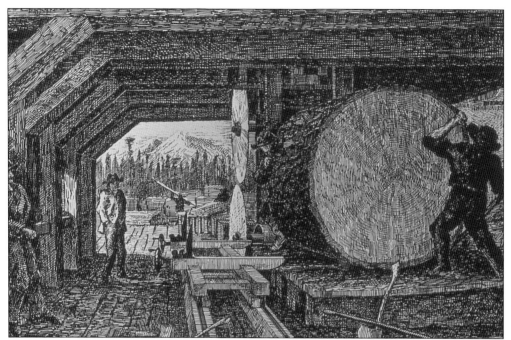

INTERIOR OF AN OLD MILL. Large circular saw blades were powered by steam engines. This Will Taylor sketch shows the dangerous work inside the saw sheds. (Courtesy of John Nopel collection.)

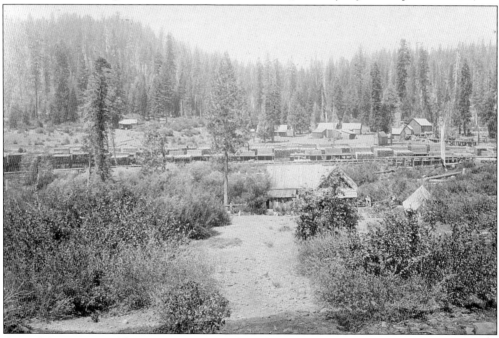

CHICO MEADOWS. In 1859, one account states that John Bidwell and partner George Woods erected a mill in Chico Meadows, just one mile north of Butte Meadows. Soon, a full-fledged seasonal logging operation grew here. Starting as the Butte Flume and Lumber Company, then becoming the Sierra Flume and Lumber Company, it finally became the Sierra Lumber Company. It was the largest mill along the Humboldt Road. (Courtesy of John Nopel collection.)

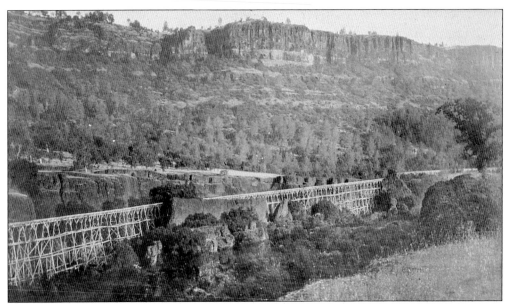

THE FLUME. To reduce the high costs of moving milled wood from the mountains, the Butte Flume and Lumber Company completed its Chico Creek flume in1874. Beginning at its Chico Meadows New Arcade Mill, the flume snaked its way down the bottom of Chico Creek Canyon. The V-shaped flume was not designed to carry logs but rough-cut boards. It passed through huge blocks of basalt rock that can be easily identified today across from the Devil's Kitchen parking area in Chico's Bidwell Park. (Courtesy of John Nopel collection.)

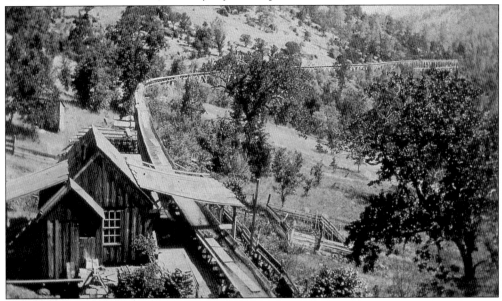

CHINA SWITCH STATION. There were several flume-tender cabins established along the flume. Tenders patrolled up and down from the cabins, maintaining smooth movement of boards coming down. Note boards in the flume here. This cabin was in the canyon below Forest Ranch opposite the10 Mile House at McGann Ranch. In some places the flume was about 100 feet high. (Courtesy John Nopel Collection and California State University, Chico, Meriam Library, Special Collections.)

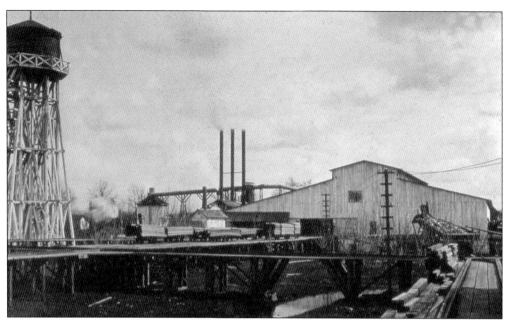

SIERRA LUMBER COMPANY. The first flume "dump" was on the south side of Chico Creek across from the lower end of today's Bidwell Park Golf Course. A cluster of manufacturing operations called Oakvale sprang up there. In 1876, the flume extended into Chico. A larger industrial plant, shown here, was built just east of today's Pine Street along the Humboldt Road. The Sierra Lumber Company became the biggest and most complex single lumber operation in the world. (Courtesy of John Nopel collection.)

WEST BRANCH MILL. In 1878, the Sierra Flume and Lumber Company became just the Sierra Lumber Company. In the mid-1890s, Sierra closed its Chico Meadows mill. It established a new mill community, known as the Providence or West Branch Mill, in the bottom of Chico Creek Canyon where Campbell Creek flows into Chico Creek today. The mill was accessed from the West Branch stop of the Humboldt Road on the ridge top above. (Courtesy of Sara King collection.)

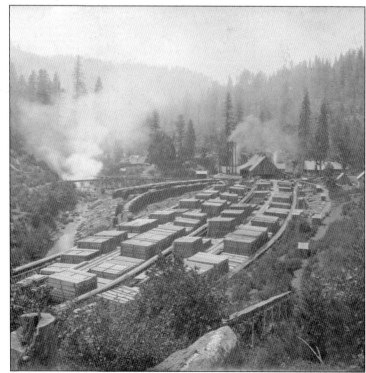

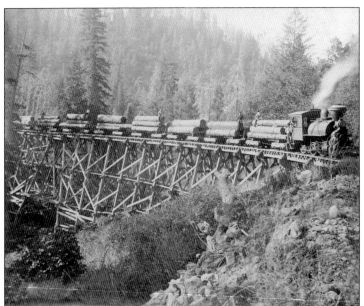

CROSSING CHICO CREEK CANYON, ABOUT 1902. At the Providence Mill, Sierra Lumber used "meter-gauge" railroad lines to move downed logs to the mill. A small steam engine brings a string of cars across the trestle over Big Chico Creek, just upstream from the mill site. Milled, rough-cut boards were floated down the existing Chico Creek flume to Sierra's finishing mills in Chico. (Courtesy of Sara King collection.)

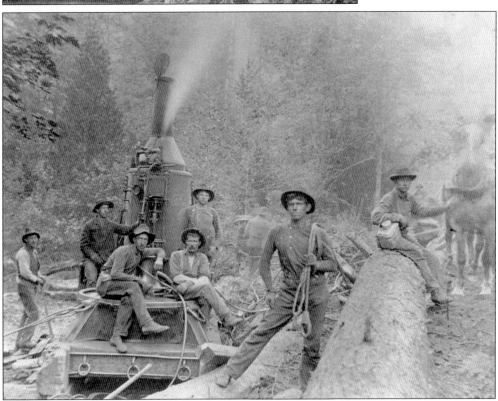

LUMBER CREW NEAR LOMO. In 1881, John Dolbeer built and first used his "steam donkey" engines in the redwood forests. In 1886, Sierra Lumber Company was probably the first to bring the steam-powered Dolbeers to the Sierra-Cascade Mountains. They were used at Chico Meadows. These powerful winches increased capabilities to move downed logs to the mills. (Courtesy of California State University, Chico, Meriam Library, Special Collections.)

MILL WORKERS LIFE. A sizable seasonal community sprang up at the Providence Mill. Here, Charles and Nellie Shuffleton Weber sit in front of their cabin with their daughter Ruth. Several years after this picture was taken, the Weber family moved to the property owned by Nellie's parents in Forest Ranch. Ruth would finish the eighth grade there. (Courtesy of John Nopel collection.)

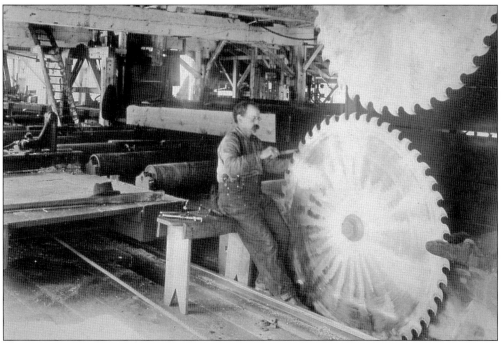

THE FILER. One of the highest-paying jobs in the lumber mills was the saw filer. Referred to as the "aristocrat of the mill," he could earn up to $100 a month. Here, filer Doc Bisphain sharpens the big circular blades at the Providence Mill. (Courtesy of John Nopel collection.)

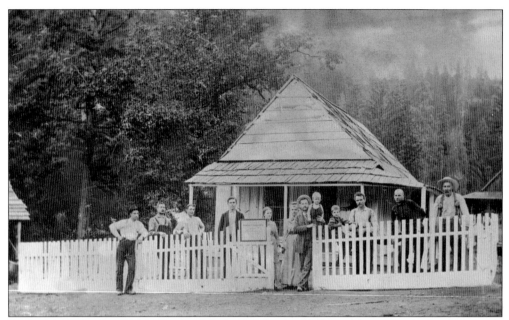

EARLY MEDICAL CARE. Dr. Newton Thomas Enloe worked as a physician for Sierra Lumber Company. He established this "hospital" at West Branch. Enloe is standing by the gate holding his son. Differing accounts place the hospital at the Providence mill site in the bottom of Chico Creek Canyon or on the ridge at the West Branch stop on the Humboldt Road. (Courtesy of John Nopel collection.)

DOCTOR ENLOE'S OFFICE. At Dr. Newton Thomas Enloe's West Branch hospital, he provided full medical care for Sierra Lumber Company employees for $1 per month. In 1907, the incoming Diamond Match Company bought out Sierra Lumber. Enloe worked for Diamond until 1913, when he located to Chico. He established a public hospital at 330 Flume Street, which evolved into today's regional hospital. (Courtesy of John Nopel collection.)

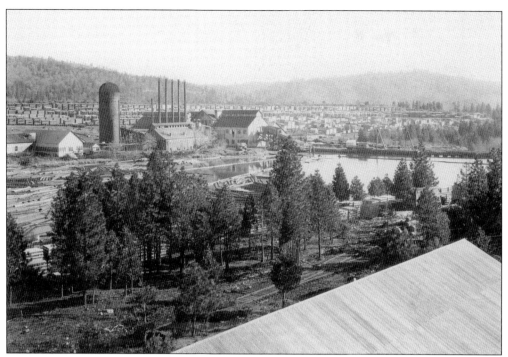

DIAMOND MATCH COMPANY. In 1901, the Diamond Match Company, based in Ohio, purchased nearly 70,000 acres of timberland in Northern California. Diamond built a state-of-the-trade mountain mill and town at Stirling City, east of today's Paradise and Magalia in Butte County. It connected via a 32-mile railroad to Chico, where a large industrial plant was built. In 1907, Diamond bought the Sierra Lumber Company's 93,000 mountain acreage. (Courtesy of John Nopel collection.)

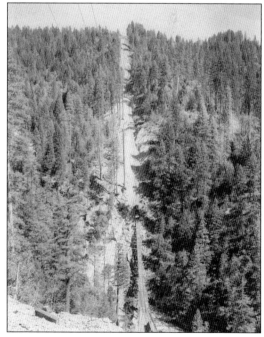

THE INCLINE. In 1926–1927, Diamond planned and built its famous "double incline" to reach an isolated stand of trees on the west side of Butte Creek near the Humboldt Road. Giant electrical hoists were placed on the ridge tops on both sides of Butte Creek. Railroad cars were lowered and pulled up across Butte Creek canyon. Harvested logs could be moved to the Stirling City mill. (Courtesy of John Nopel collection.)

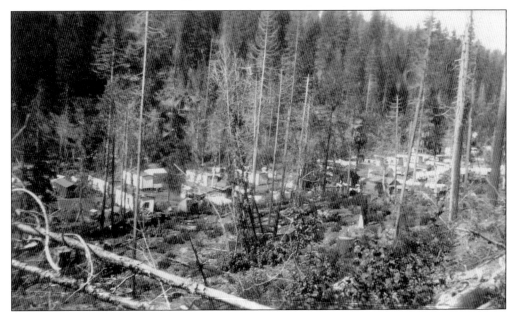

WEST BRANCH LOGGING CAMP, 1929. Diamond Match established a seasonal logging camp along the West Branch of Butte Creek, two miles south of the Humboldt Road. This camp operated from 1929 through 1934. Diamond provided movable cabins for workers. Single men shared cabin space. Families rented their own cabins. The West Branch Camp was linked by railroad to Diamond's Stirling City mill, but many supplies traveled over the Humboldt Road to Chico. (Courtesy of Clifford Gilbert collection.)

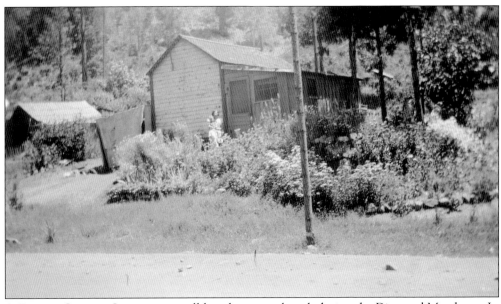

A FLOWER GARDEN. Logging was still largely seasonal work during the Diamond Match era. In Diamond's lumber camp, every house looked the same, but over time, families would add touches to make them "homier." In this photograph is Blackie Gilbert's mom, Kate, who planted a flower garden each summer to soften the boxy shape. (Courtesy of Clifford Gilbert collection.)

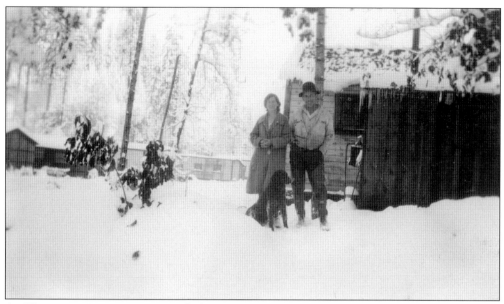

AT HOME IN A LOGGING CAMP. Blackie Gilbert's parents, Kate and Mark Gilbert, stand with the camp dog Spike. When asked if it was a lonely life, Blackie recalled, "There was a mill dance potluck or social every Saturday. Everyone helped each other. The camp baker was French and made excellent pastries. Every few weeks someone would take a sled through the snow, down the hill to Taggart's, to get supplies and bring things back for everyone." (Courtesy of Clifford Gilbert collection.)

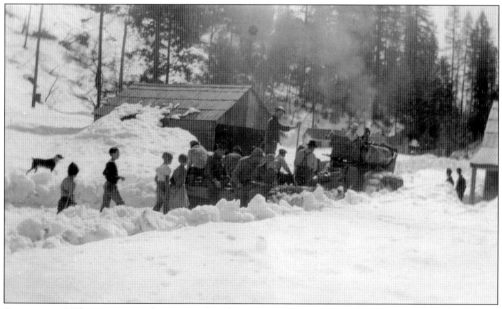

SPRINGTIME! The camp was about 13 miles above Forest Ranch and could get as much as eight feet of snow during the winter, so it was seasonal work from about late March to November. Everyone was always happy to see the first snowplow and some dirt after a long winter. Then work started, six days a week, 10 hours a day. (Courtesy of Clifford Gilbert collection.)

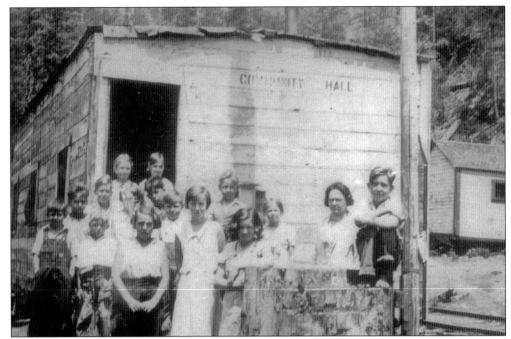

WEST BRANCH SCHOOL. The first school for the kids whose parents worked at West Branch was in a small cabin like one of the seasonal residences. High waters damaged it one winter, so the school moved to this newer building, which also served as the community center. There were meetings and small parties there. Blackie Gilbert graduated from the eighth grade at this school. (Courtesy of Clifford Gilbert collection.)

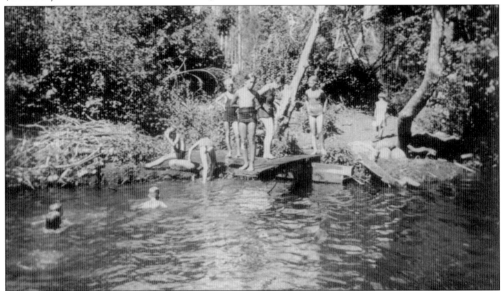

SWIMMIN' HOLE. Just before summer, a "cat" (tractor) would dam the creek to make a pool. Babies, kids, and adults used it. After work, the loggers would swim and cool off, too. Blackie Gilbert is the boy about to jump off the end of the diving board. He recalled, "We kids went everywhere as long as we told our folks where we were going and were home by dark. We fished, explored, and swam all summer." (Courtesy of Clifford Gilbert collection.)

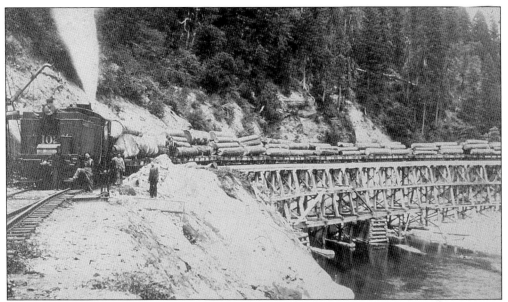

STIRLING CITY MILL TRAIN. For more than 50 years, from 1904 to 1957, Diamond Match and its Stirling City mill comprised one of the largest logging operations in the American West. Diamond used extensive railroad lines to carry out the work. Some lines were used over many years, and some temporary lines were used, then moved, as logging locations shifted. Lines funneled into Stirling City where logs were cut up and then shipped by railroad to the large remanufacturing plants in Chico. (Courtesy of John Nopel collection.)

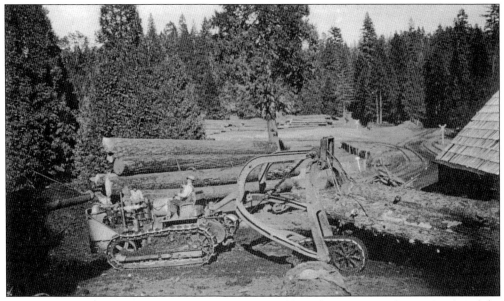

LOGGING ARCH AND GAS CATERPILLAR. Diamond's double-incline crossing of Butte Creek and the later railroad mainline into Butte Meadows, built in 1936, allowed major logging operations along and below the Humboldt Road. This mid-1930s picture shows Diamond equipment from its West Branch camp working at the old West Branch stop on the road. A temporary railroad line ran close to the road, and a railroad crossing sign can be seen in the picture. Large caterpillar tractors were becoming standard equipment in the woods. (Courtesy of Clifford Gilbert collection.)

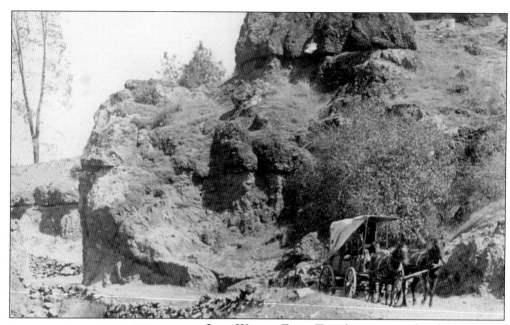

IRON WHEELS FADE. Traveling west on the old Humboldt Wagon Road in the 1890s, this buggy is about 10 miles from Chico. This was the last decade in which hay-fueled horsepower would be the only mode of transportation on the road. Between 1895 and 1902, automobiles started to appear on California roads. (Courtesy of California State University, Chico, Meriam Library, Special Collections.)

ANNA MARKS, 1905. Born in 1886, Anna Marks lived in Chico and vacationed in Butte Meadows during a time when the automobile transformed American life. Her photographic chronicle of her life provides a window into this transition for the Humboldt Wagon Road. Known as a respected businesswoman, she was a bookkeeper and the first woman to serve on the Bidwell Memorial Presbyterian Church Board of Trustees. (Courtesy of Anna Marks collection.)

Four

NEW WHEELS
ON THE ROAD

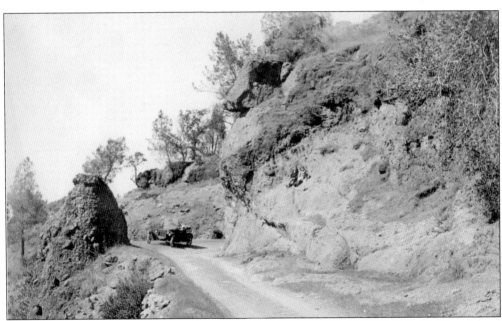

NEW WHEELS ON THE ROAD. Anna Marks snapped this picture of an automobile that belonged to friends. Seen at the County Seat Grade on old Humboldt Wagon Road, it is coming around the curve, heading toward Chico. Early designs of touring cars were based on the open design of horse and wagon transports. Drivers and passengers still needed to wear dusters, goggles, and gloves for protection from the elements. (Courtesy of Anna Marks collection.)

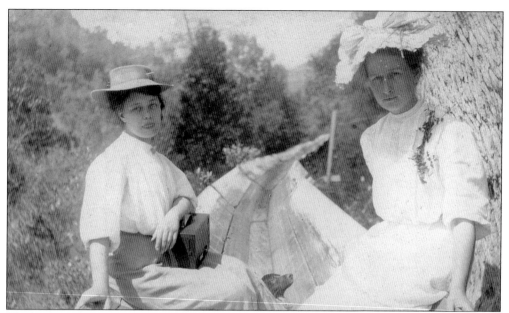

THE BOX CAMERA. It seems Anna was never without a camera, as seen here on her lap. Her four photograph albums, dating from 1900, are treasured family heirlooms. This photograph, taken in 1907 in Iron Canyon along Big Chico Creek, shows Anna and Litta Swearingen. They are sitting in the Sierra Lumber Company Flume. Jack, the dog, is in the middle. (Courtesy of Anna Marks collection.)

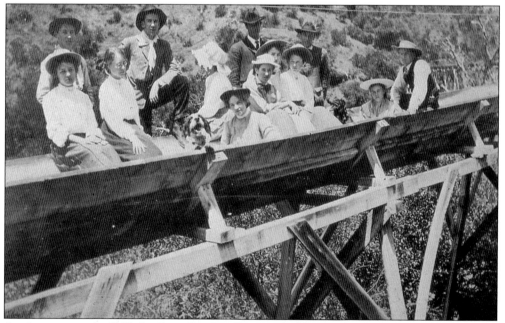

AN ADVENTURE. In 1907, the Sierra Lumber Company sold its land and facilities to the Diamond Match Company. The old flume system from the mountains was abandoned. Though discouraged by Sierra, the flume was used recreationally as an outing destination. People were allowed to scavenge wood from the structure. In remote areas, the flume deteriorated and collapsed. Today, very little remains of the once famous conveyance. (Courtesy of Anna Marks collection.)

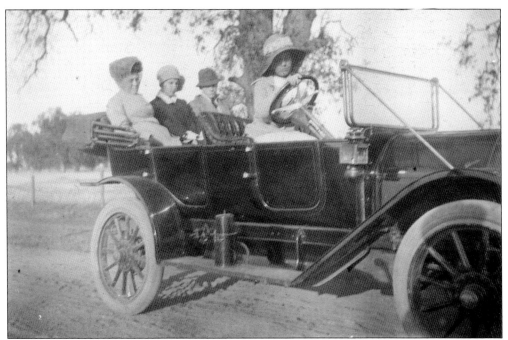

ANNA'S FIRST DRIVING LESSON. Anna Marks's sister Reba claimed Anna was the first woman in Chico to get a driver's license. Anna's nephew Tom Marks remembered driving with Anna from Chico to Butte Meadows. Anna drove in the middle of the Humboldt Road, carefully honking as she rounded every curve. Anna's last car was a 1939 Buick, which was sold to "Junkie George" in Chico. Cataracts ended her driving days. (Courtesy of Anna Marks collection.)

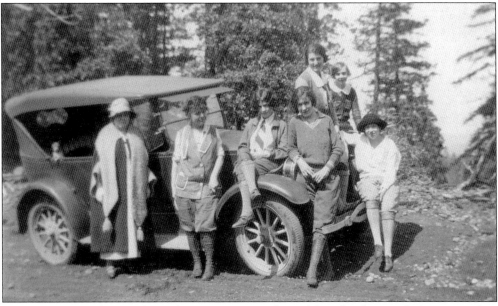

ON THE ROAD. Taken in the mid-1920s, Anna Marks and friends, along with Anna's mother, are now traveling more comfortably by automobile. Penny Nopel recalled that Anna had a group of close girlfriends. They called themselves "the Gaiety Girls" and enjoyed nothing better than outings or parties. (Courtesy of Anna Marks collection.)

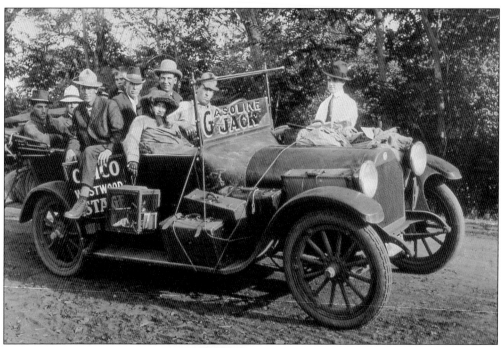

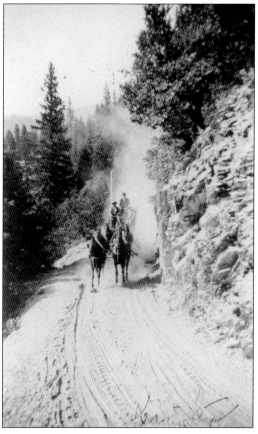

CHICO TO WESTWOOD STAGE. Jack Houk, nicknamed "Gasoline Jack," partnered with John Smith to operate a new kind of "stagecoach" on the Humboldt Road. Passengers may have been even less comfortable than riding in horse-drawn stagecoaches. (Courtesy of John Nopel collection.)

SHARING THE ROAD. At the turn of the 20th century, both horse-drawn conveyances and motorized trucks and automobiles were sharing the road. One can see the tracks of an automobile or truck in the dust in front of the horses. Dust could get ankle deep on the road. (Courtesy of Chester-Lake Almanor Museum.)

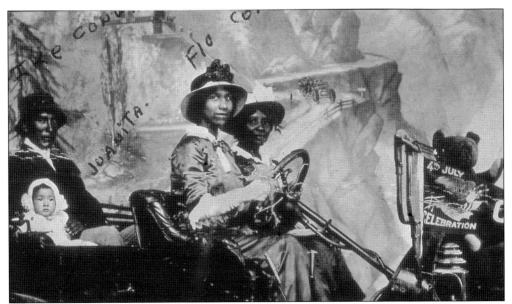

TAKING A DRIVE. Automobiles quickly became status symbols. In 1910, the Conway family had this studio portrait taken in an early automobile. Written on the photograph back was, "Chico Indians. Ike Conway, Juanita [Conway] in back seat. Flo Conway at driver's wheel [Ike's first wife]. [Juanita 18 months]." William J. Conway, a Mechoopda Indian, served as Annie Bidwell's driver around 1913. (Courtesy of John Nopel collection.)

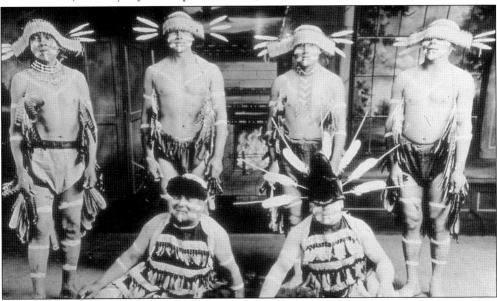

STRUGGLE FOR CULTURAL RECOVERY. These Mechoopda Maidu men were photographed in ceremonial costume while performing in a "road show." Those pictured are, from left to right, (first row) Billie Conway and Dewey Conway; (second row) George Nye, Isaiah Conway, Jody Conway, and Herb Young. Other photographs of the time show Conway men in a brass band with French horns and trumpets. Concurrently, Mountain Maidu pressed a claim for lands taken without compensation around the greater Big Meadows area. They received 75¢ an acre. (Courtesy of John Nopel collection.)

SHUFFLETON STORE. Parents Lucy Nopel Shuffleton and Harry Shuffleton pose with their daughter Margaret Christine in front of the Forest Ranch Post Office around 1926. Apparently, Harry has killed the bear draped over the pack horse. Harry, only son of John and Margaret Shuffleton, had inherited his parents' extensive Forest Ranch properties. (Courtesy of John Nopel collection.)

CHRISTINE SHUFFLETON. After the earlier Forest Ranch Hotel faded away, the Shuffleton Store became the next center of Forest Ranch. Christine grew up there and attended the Forest Ranch School. (Courtesy of John Nopel Collection.)

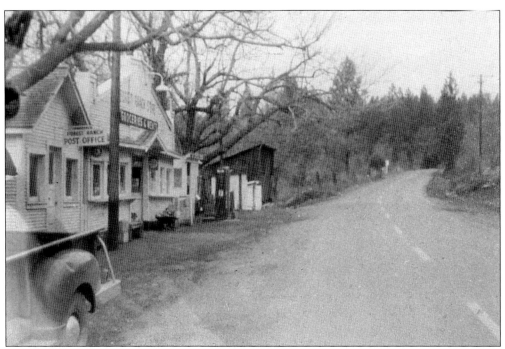

STATE ROUTE 47. Many people remembered that State Route 47, the paved Humboldt Road from Chico to Highway 36 near Chester and Lassen Volcanic National Park, passed in front of a huge Royal Anne cherry tree. It grew right outside Shuffleton's store. Harry Shuffleton, whose father, John Henry Shuffleton, planted it, billed it as "the biggest cherry tree in the world." Each lane of the road was about 15 feet wide. (Courtesy of John Nopel collection.)

HIGH SCHOOL, 1906. Sixteen-year-old Leona (right) and her older sister Nancy Halley attended Chico High School. Like all students their age in Forest Ranch, they had to board in Chico as the distance was too great to go back and forth every day. (Courtesy of Aileen Selvester collection.)

TIME TO RELAX. Pictured are, from left to right, Presley W. Halley, his wife, Mary Jane, friend Leona West sitting with her son, and daughter Leona Halley. Presley gave the land for the Forest Ranch Cemetery. When two little girls in the community died, Presley built the coffins and performed the funeral service. He died in 1915, but the property remained in the family. (Courtesy of Aileen Selvester collection.)

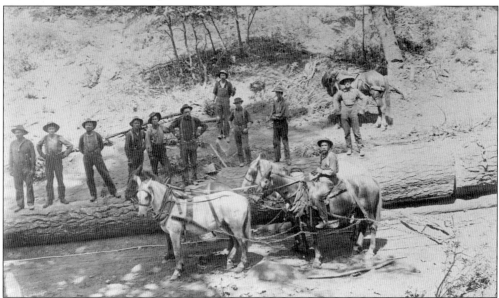

LOGGING WAGES BUILT THE ECONOMY. Hundreds of men and women who lived in the communities along the Humboldt Road found work "in the woods" as loggers, laundresses, cooks, nurses and other occupations. Leona Halley Taggart's brother, Glenn, was a member of this logging crew. He became a professional trumpet musician and head arranger for Warner Brothers Studios. (Courtesy John Nopel Collection and California State University, Chico, Meriam Library, Special Collections.)

LAND PASSES TO A NEW GENERATION.
In 1919, Leona married Douglas Taggart.
In 1933, they lost their valley home
during the Depression and moved back
to the Halley property in Forest Ranch.
Automobile traffic was increasing on
Humboldt Road. As an enterprising
couple, in 1935, they decided to build a
gas station where cowboys driving cattle
had once been welcomed. (Courtesy
of Aileen Selvester collection.)

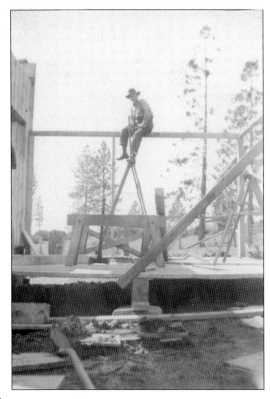

CAREFREE. The Taggarts' neighbor John
Newhart had accidentally cut timber on
land that belonged to Douglas and Leona.
To repay them for his mistake, Newhart
built a new building for them. Apparently,
there was no required dress code for Aileen
Taggart Selvester to watch Newhart at
work. Here, she is about 18 months old.
(Courtesy of Aileen Selvester collection.)

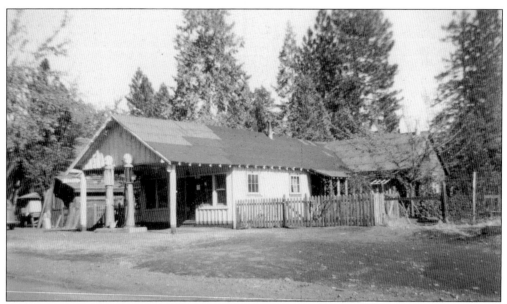

THE CEDARS, ABOUT 1940. Carl Dodge, son of James and Laura Dodge, operated a post office and the first telephone line between Chico and the Shuffleton store. The Taggarts bought the line from Carl. Called the Butte Meadows Telephone and Telegraph Company, they extended it from Shuffleton's to Butte Meadows. Robert Taggart, Aileen's older brother, was in the service a few years later. He called free from Germany as the Taggarts owned the lines. (Courtesy of Aileen Selvester collection.)

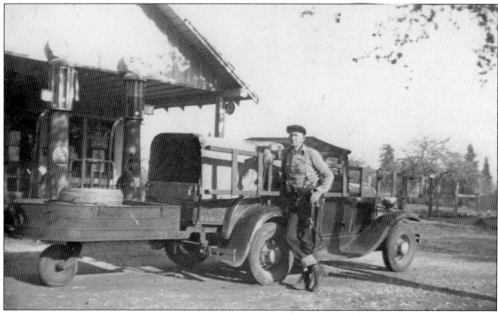

DOUGLAS TAGGART, ABOUT 1950. The Cedars was a Shell gas station and general store where drivers could also get lunch. Aileen remembers the company painted buildings as well as installed "patent" toilets and kept them maintained. The stop was a necessity for cars that would often get vapor lock coming up the Humboldt Road from Chico. The gas station and store operated until the 1950s. (Courtesy of Aileen Selvester collection.)

LEONA TAGGART, ABOUT 1960. Aileen Selvester Taggart said, "You did what you had to during the Depression." In the winter, there were no snowplows, and the family often could not get to Chico. Leona petitioned to have a post office designated at the Cedars. After the petition was granted, the government plowed the road. Leona is standing in her home with a square Grand Knabe piano that belonged to Douglas's mother. (Courtesy of Aileen Selvester collection.)

LUCILE LAURAINE. Acting as postmaster for the towns along the Humboldt Road was a time-honored position for women, even in pioneer days. It could be done from home, it paid well, and it kept them engaged in town news. Often, there was extra income from a store attached to the post office. Lucile was the Forest Ranch postmaster from 1955 to 1964 and an early president of the Forest Ranch Women's Club. (Courtesy of John Nopel collection.)

MARGE SCHOEN, BUTTE MEADOWS.
Marge Schoen was the postmaster during the 1940s just after telephone service came into Butte Meadows. When game wardens or law enforcement came up from Chico, Forest Ranch residents had a special ring to alert the Taggarts who then called the Schoens and alerted them to hide the slot machine they had at the store. Over at West Branch, Blackie Gilbert said his mom would know to heat the stew without deer meat to serve the game warden. (Courtesy of John Nopel collection.)

FIRST DAY OF SCHOOL. Eight-year-old Margaret Aileen Halley Taggart is ready for her first day of third grade in 1933. She has a new dress and a new haircut. It was a three-mile walk to her one-room schoolhouse in Forest Ranch. There were only about five students at the school during that time. (Courtesy of Aileen Selvester collection.)

FOREST RANCH SCHOOLS. There have been five public school buildings in Forest Ranch, counting today's Forest Ranch Charter School. Following a petition from community families to Butte County, the first school was established in 1878. Fires destroyed the first three school buildings; the fourth building was retired when the present school complex was opened in 1992. (Courtesy of John Nopel collection.)

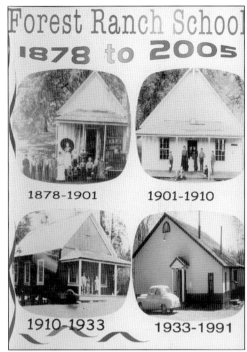

DOE MILL RIDGE, 1940. A narrow road across Little Chico Creek connects Doe Mill Ridge to the Humboldt Road at Forest Ranch. The road was the main connection to services for usually self-sufficient Ridge residents. Bill and Lizzie Dorrett grew fruit trees and vegetables on their Ridge homestead and hunted most of their meat. She ran a small store there. In this picture, Bill is in the center and Lizzie's brother John Wilson is on his right. The man on Bill's left is unidentified. (Courtesy of Sara King collection.)

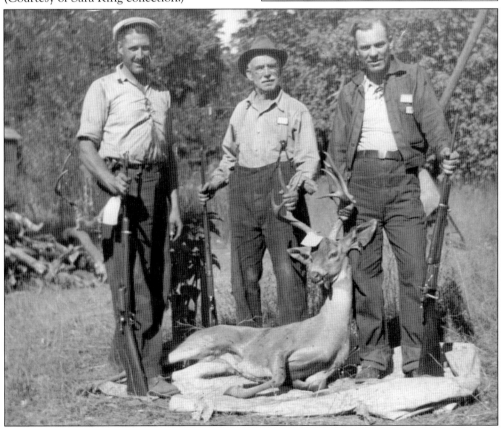

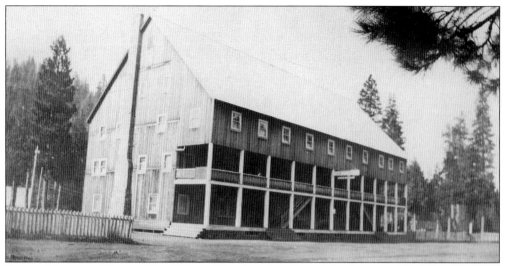

BUTTE MEADOWS HOTEL. The fifth and last hotel in Butte Meadows was the large four-story building shown here, called the Roper or Butte Meadows Hotel. The Roper family complex of buildings included the hotel, with post office, dining room, and store. A dance hall, tank house, and shop were nearby. Catering to the changes coming on the road, it also had a blacksmith and automobile garage. (Courtesy of Barbara Greene Maggi collection.)

ON THE PORCH. At their Butte Meadows cabin are, from left to right, (first row) Anna Marks's sister Reba, her brother Harvey, and Anna; (second row) Uncle John Nourse (brother to Anna's mother), Ann Nourse Marks, and Anna's father, Isaiah George Marks. Reba remembered that before automobiles, the family would drive their horse and buggy to their cabin, leaving home in Chico at 3:00 a.m. and arriving in Butte Meadows at 3:00 p.m., 12 hours later. (Courtesy of Anna Marks collection.)

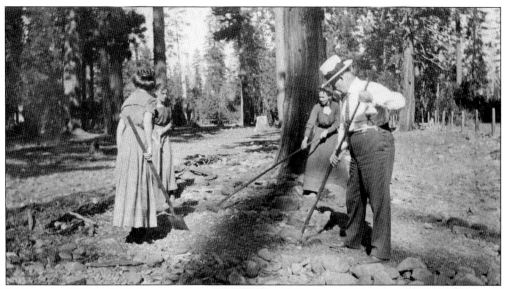

IMPROVEMENT CLUB, 1912.
Property owners took care of
what road maintenance they
could. Barbara Greene Maggi,
granddaughter of the Stephens
who owned the Jonesville Hotel,
reported that one of the summer
jobs for the children was to
remove large rocks from the wagon
tracks on the road. Margaret
Tartar said summer work on
the Ruffa ranch included hand
raking the stage route. Pictured
is Anna Marks's family at work
in Butte Meadows. (Courtesy
of Anna Marks collection.)

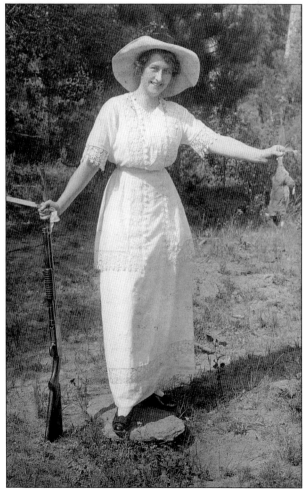

FOOLIN' AROUND. Anna Marks's
friend Litta Swearingen clowns
for the photographer. Hunting
guns were a standard part of life
along the Humboldt Road, but
there were no guarantees as to
what a person might bag. Being
properly dressed for the hunt,
however, might have meant a
more satisfying result. (Courtesy
of Anna Marks collection.)

SHIRLEY'S MULE. Anna's niece Elizabeth Mohr recalled that Anna had a heart of gold and could be ready for an adventure at a moment's notice. Anna, at the tail end of this beleaguered donkey, is obviously having a great time! The photograph is from Anna's album with the handwritten caption, but it does not say who Shirley might be. (Courtesy of Anna Marks collection.)

KEEPING COOL. Air conditioning was not widely available in the valley until after World War II. The automobile made it possible for more people to get to the mountains for weekends or longer vacations. The Humboldt Road connection made Butte Meadows and Jonesville even more popular spots to escape oppressive summer heat. (Courtesy of Anna Marks collection.)

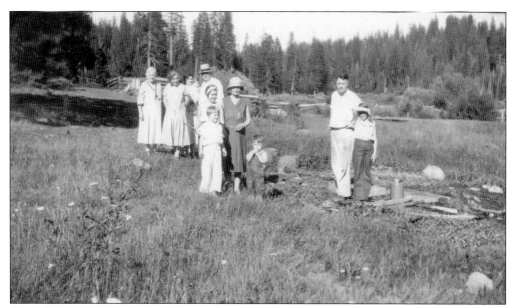

COLD SPRING OUTING, 1932. The "Big Spring" at Chico Meadows was often a picnic destination for families from Butte Meadows. In the middle of the meadow, the spring gushed out of the ground in a constant, copious, cold flow and into Chico Creek. Spring water was carried away in jugs and containers to camps and cabins. Today, the spring is covered and fenced in for use by the nearby Boy Scout Camp. (Courtesy of Anna Marks collection.)

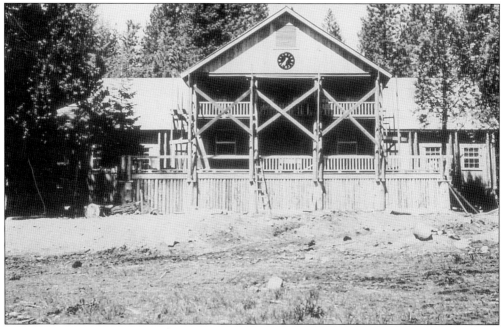

CAMP LASSEN LODGE. In 1924, the Boy Scouts of America established summer campsite Camp Na Wa Kwa in Humbug Valley, Plumas County. For several reasons, it was abandoned 10 years later, and a new camp, Camp Lassen, was built at Chico Meadows. The camp lodge, under construction here, was started in the fall of 1936 and completed the following year. Camp Lassen celebrated 75 years of activity in 2009. (Courtesy of John Nopel collection.)

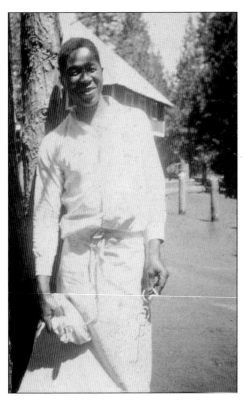

JIMMIE LEE, 1937. Tens of thousands of automobile trips over the Humboldt Road brought people of all ages, inclinations, and interests in and out of Camp Lassen. The focus has always been on healthy and engaging activities in a beautiful mountain setting. One of the best-remembered staff members was Jimmie Lee, an unflappable camp cook and friend to all the campers. (Courtesy of John Nopel collection.)

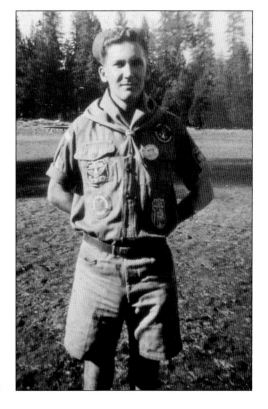

JOHN NOPEL, 1936. During the 1920s and 1930s, the Boy Scout experience, under local Scout executive Harry B. Ogle, was influential for many Northern California boys and young men, especially their time spent at Camp Lassen. One such young man was Eagle Scout John Nopel who had a lifelong interest in Butte County history and the Humboldt Road. His spirit permeates this book. He remained a Scout member to the end of his life's trail. (Courtesy of John Nopel collection.)

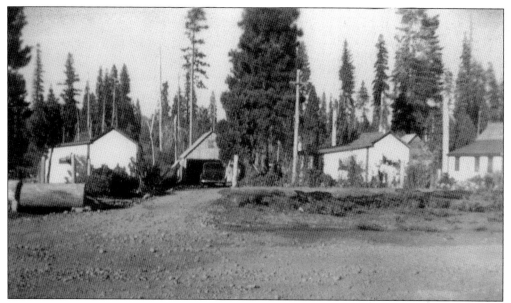

BUTTE MEADOWS LOGGING CAMP. In late 1936, Diamond match crews built a railroad mainline to Butte Meadows from Stirling City. Diamond established its Butte Meadows Camp in the area behind today's fire station, and the large seasonal community would remain there until 1953. Blackie Gilbert's parents had their cabin moved by railroad to the new camp. (Courtesy of Clifford Gilbert collection.)

DENN'S RESTAURANT. During the summer, Butte Meadows was one of the most populous communities along the road. It offered lodging, merchandise sales, transportation, and recreation. Many stores, restaurants, and bars have come and gone over the years. Here, Denn's Cabins is pictured in the mid-1950s. Homer Speegle built the first store structure at this site in 1925. The outlet then became Chatfields, Schoen's Store, and Denn's. Today, it is the Outpost. (Courtesy of John Nopel collection.)

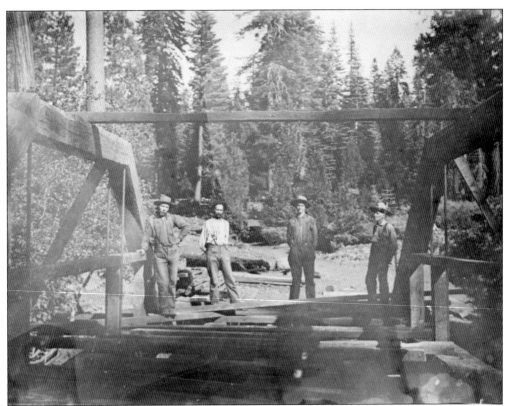

ROAD CONTRACTORS. The Dodge family worked as contractors to maintain the road. Albert Dodge is on the left side of the bridge, James Dodge, patriarch and Head Overseer, is next to Albert. Henry Dodge, a middle son is next to James, and the man on the right is unidentified. In 1899, a Chico newspaper reported that General Bidwell paid James for one day of labor and Albert for three days of labor. The article also noted Jack Lucas had contributed $50 to help pay for upkeep of the road. (Courtesy of Otis and Shirlon Dodge collection.)

BUTTE MEADOWS BRIDGE. The Humboldt Road crossed only two major waterways between Chico and Susanville: Butte Creek at Butte Meadows and the North Fork of the Feather River at Big Meadows. Both crossings were simple fords early on, but Butte Creek has had several spans over a century and more. This picture of the "old" bridge shows the wooden beams and rock abutments used in early construction. (Courtesy of Anna Marks collection.)

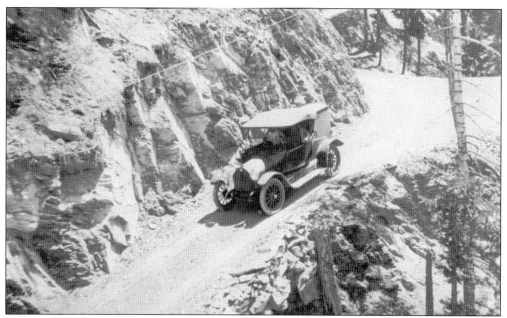

CHERRY HILL BOUND. Cherry Hill was about four miles from central Butte Meadows. This car traveled over rock work shoring up the road for wagons that may still have used the road. Gas was not a problem to fuel early cars. It was used for machinery and farm equipment. Tires, however, could be a limiting factor when out for pleasure drives. Getting 1,000 miles on tires was considered good. (Courtesy of California State University, Chico, Meriam Library, Special Collections.)

ON THE SUMMIT, JULY 1932. The Humboldt Wagon Road crossed the Sierra-Cascade crest line at the Jonesville Summit or Big Summit at a 6,610-foot elevation. Nearby, the Humboldt Peak reaches 7,087 feet and is one of the highest points for miles in both directions. It was a long six-mile climb from Jonesville to the Big Summit, but the spectacular views and lingering snowfields made it a memorable milestone. (Courtesy of Anna Marks collection.)

DORRETT FAMILY AT THE SUMMIT. Lizzie (center) and Bill Dorrett (right) sit on a log at the Humboldt Summit with their friend Arlene and Lizzie's brother John Wilson. Dogs Billy and Major are also enjoying the views. Though Lizzie and Bill had been born into a world of wagons pulled by draft animals, here they travel in a "horseless carriage." A new era is emerging. (Courtesy of Sara King collection.)

WADE AND MARIE TARTAR. Wade Tartar's mother died when he was young and he came to live with his Aunt Emma and Charlie Ruffa. Eventually, Wade inherited and ran the Ruffa ranches in Vina and Butt Valley. Wade married Margaret Garrison in 1930. His daughter Marie, shown here, was born during his first marriage but grew up with Wade and Margaret. The landmark Eagle Rocks stand out on the horizon above Ruffa Ranch. (Courtesy Dan Heal, from the Margaret Tartar gift collection.)

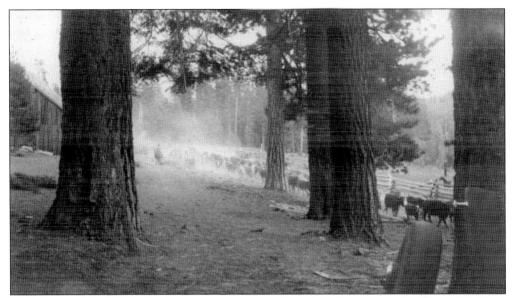

FALL ROUND UP, 1937. Cattlemen continued to drive their herds over the Humboldt Road during most of the 20th century. Louie Ruffa charged cowboys $1 a head for cattle grazing and hay. At the end of summer, some cattlemen stayed one to three days to rest their cattle before the long push up over the summit to Jonesville. (Courtesy Dan Heal, from the Margaret Tartar gift collection.)

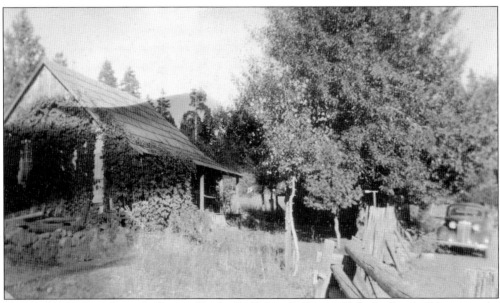

CHARLIE AND EMMA RUFFA'S CABIN. Charlie Ruffa bought Doctor Enloe's office building to make a new home for him and Emma. Located at the defunct West Branch stage stop, it cost $10. Taking it apart, transporting it over the Humboldt Road and reassembling it took Charlie most of two years. The kitchen was added later. The cabin eventually became Margaret and Wade Tartar's home. (Courtesy Dan Heal, from the Margaret Tartar gift collection.)

INSIDE MARGARET'S KITCHEN. Margaret Tartar's friend Beverly Benner Ogle remembered visiting Wade and Margaret's cabin. She said, "I don't know how she did it, but before she even saw you coming, Margaret would have made a fresh pot of coffee. You could smell that wonderful aroma coming from her cabin." The Tartars were married 51 years. After Wade died, Margaret continued to spend summers living on her own at the cabin. It had no electricity. (Courtesy of Dan Heal, from the Margaret Tartar gift collection.)

MARGARET TARTAR. Margaret loved animals and life at the Ruffa Ranch. She kept a water-cooled box of vegetables to feed deer. She named each one who came for a handout and did the same for the local chipmunks. Her friend Dan Heal remembered some of the chipmunk names—Split Ear, Molly, and Spike Tail. (Courtesy of Dan Heal, from the Margaret Tartar gift collection.)

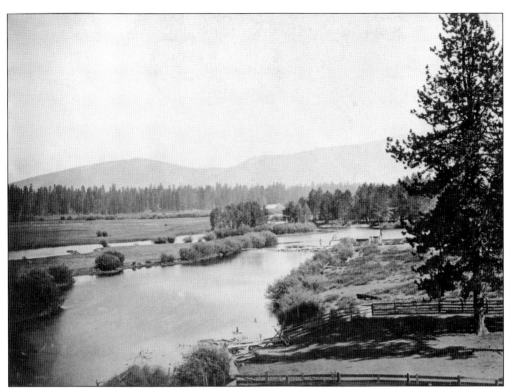

PRATTVILLE'S LAST DAYS. This scene of Big Meadows was taken from the Prattville Hotel. Bunnell's Hotel is shown in the distance. Prattville limped along after the fire of 1909 almost destroyed it. Lake Almanor started to inundate it after the dam was completed in 1914. Prattville continued to be the center of the community until Chester was established in 1911. (Courtesy of Plumas County Museum.)

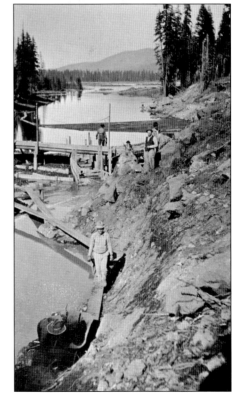

BUILDING LAKE ALMANOR DAM. Great Western Power Company officials bought out local ranchers, keeping their plans for a reservoir secret. Prattville burned in a fire that many thought was set by the company. In 1914, when the dam was completed, the rising waters slowly erased a way of life for the ranchers, lumbermen, and Prattville resort owners. The Humboldt Road rerouted through Chester. (Courtesy of California State University, Chico, Meriam Library, Special Collections.)

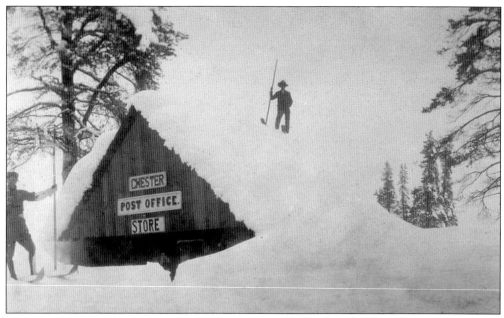

FIRST CHESTER POST OFFICE AND STORE. With Prattville flooded, the Olsens, Stovers, Johnsons and Martins established Chester on the western side of Big Meadows. The Olsens built a post office and Maude Gay, a family cousin, served as postmaster for more than 30 years. Chester could be reached using sections of road that were once the Humboldt Road that connected Prattville to the western side of Big Meadows. (Courtesy Chester-Lake Almanor Museum.)

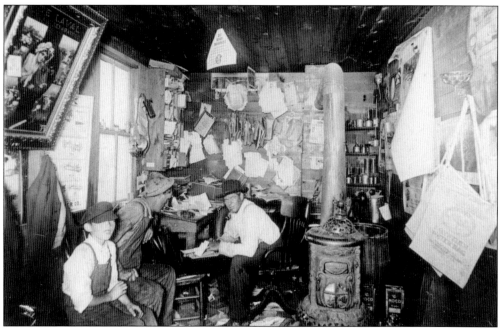

INSIDE THE CHESTER POST OFFICE. Till Randall, a relative of Postmaster Maude Gay, sits at the desk with a pipe in his mouth. Sorting the mail in the midst of all these other papers must have been a challenge. It was a small town as can be seen by the few mail slots on the left wall. Note the many oilcans. (Courtesy of Chester-Lake Almanor Museum.)

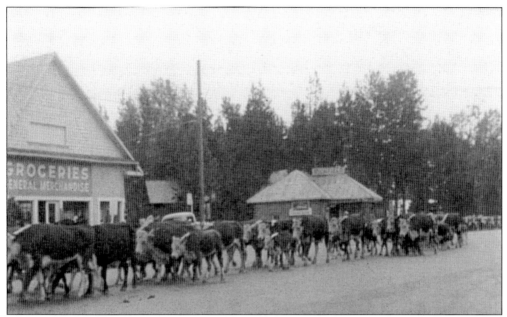

CHESTER CATTLE DRIVE, ABOUT 1930. A herd comes through the middle of Chester. As paved roads increased motorized traffic, traditional cattle drives declined. Elwin Roney led the last Roney cattle drive in 1973. Emma and George Roney said that, when coming through Chester, "dogs, children, women in their yards, and church bells caused difficulties for cowboys in keeping the herd moving." Today, cattle are trucked to summer pastures. (Courtesy of Chester-Lake Almanor Museum.)

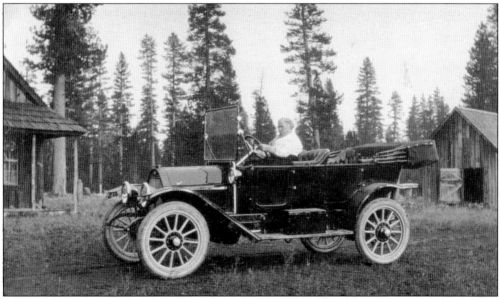

BIG MEADOWS'S FIRST CARS. The first in Big Meadows to own automobiles were the Gus Bidwell family, relatives of John Bidwell, Dr. Fred Davis Sr., and his wife, Dora, and the Stover family. The Davises owned a Maxwell. In this photograph, Ada Milroy Stover sits in her Overland automobile in front of her Big Meadows ranch house. She and her husband, Thaddeus, drove their car on the Humboldt Road as they traveled to and from their Chico winter home. Getting a car to Big Meadows was not easy. (Courtesy Chester-Lake Almanor Museum.)

RED RIVER LUMBER COMPANY, WESTWOOD. This company had the greatest lumber output of any mill in the world. In 1912, it imported draft horses to pull wagons loaded with the heavy construction equipment needed to build the mill. The horses were loaded off trains at Doyle, near Susanville, then horses and wagons traveled the old Humboldt Road to Westwood, sharing the road with motorized traffic. In 1914, the inventory for the mill listed 312 draft horses. (Courtesy of Plumas County Museum.)

DEER CREEK HIGHWAY. The rapid advancement of the automobile, expansion of electrical power throughout Northern California, and the establishment of Lassen Volcanic National Park in 1916 indicated the need for improved roads. By November 1930, construction began on the 38-mile Deer Creek addition on the old Humboldt Road, from Lomo to Deer Creek Meadows. (Courtesy of Anita Chang collection.)

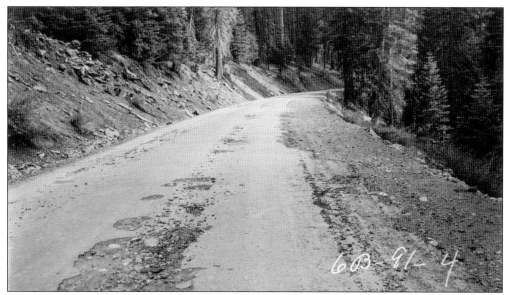

RURAL HIGHWAY CHALLENGES. As Bidwell, Francis, and Pierce knew well, thawing, freezing, and heavy vehicles—like freight wagons, stages, and trucks—created potholes and crumbling road edges. Access to the more remote reaches of the Deer Creek Highway for repairs was seasonal due to snow. Engineering was difficult, and construction was expensive, so lanes were narrow. (Courtesy of California Department of Transportation.)

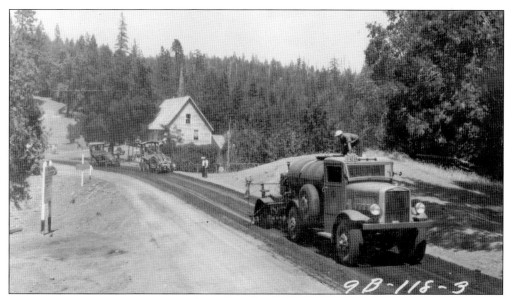

KEEPING UP WITH ROAD REPAIRS. The new Deer Creek roadway was completed in 1935 through a combination of federal, state, and county funding. The roadway from Chico to Deer Creek Meadows was designated State Route 47. In this photograph, taken in 1939, the road at Lomo is being regraded and oiled by state crews. The old Lomo hotel, which was also a stage stop on the Humboldt Road, is seen in the background. (Courtesy of California Department of Transportation.)

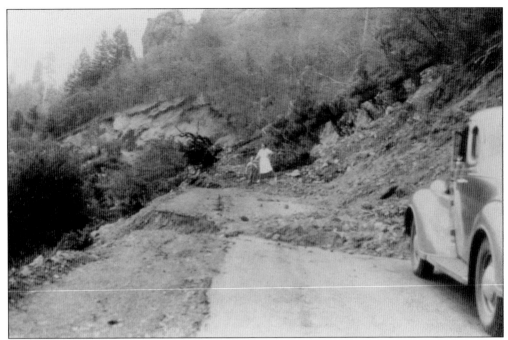

LANDSLIDE. The winter of 1936–1937 is still remembered as one of the most severe of the 20th century. The following year, another severe winter damaged the new Deer Creek Highway that had already been storm-thrashed the previous year. In 1938, all the bridges were washed out on the highway, and landslides took out parts of the road. Extensive repairs and upgrading were required. (Courtesy of Anita Chang collection, gift of Steve and Dorothy Fish.)

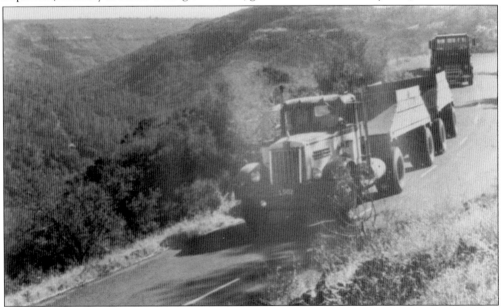

DANGERS OF THE ROAD. Logging trucks often took up both lanes as they negotiated curves. Truck and automobile drivers did not wear Hanes bells to announce their approach to oncoming traffic. Each had to honk in warning and cars often had to pull over to allow trucks to pass. A major upgrade of the old road was needed. (Courtesy of Chico *Enterprise-Record*.)

Five

RIDING INTO THE FUTURE

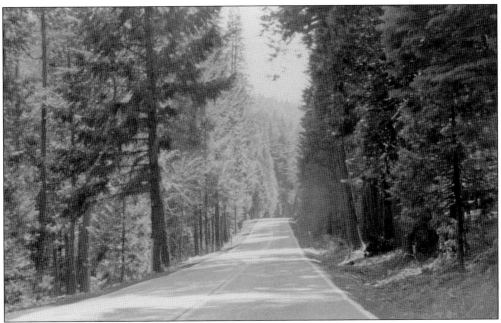

STATE HIGHWAY 32. Planning the major transformation of the old Humboldt Road into a modern state highway was carried out between 1955 and 1957. The plan called for four stages of construction. The first engineered a new start for the highway in Chico where the old Junction had been at Eighth and Ninth Streets. These streets were widened and newly paved. The second stage built a 5.4-mile section that headed east from Chico and climbed into the foothills to Hog Springs. This stage was started in January 1958. In about 1963–1964, the third stage of the project commenced. Approximately 10 miles of the old roadway between Forest Ranch and Lomo was realigned and constructed. This left, as the final stage of the project, a nine-mile section of the difficult foothill stretch from Hog Springs to Forest Ranch. It would be four years before work started on that final stage. It was completed in July 1970 at a cost of $2.2 million. (Courtesy of Anita Chang collection.)

FOREST RANCH WOMEN'S CLUB. Established in 1963, the club had three major goals: fire protection, expanded support for the local school, and, at the top of the list, an improved highway to Chico. They accomplished all these goals. Told in 1964 it would be 1974 before the road would be improved, the women decided that was too long. Donning heels, hats, and white gloves, they

met with their elected officials to protest the unsafe highway conditions. They started a letter, phone, and publicity campaign and pushed the construction start date up by four years. (Courtesy of Forest Ranch Women's Club collection.)

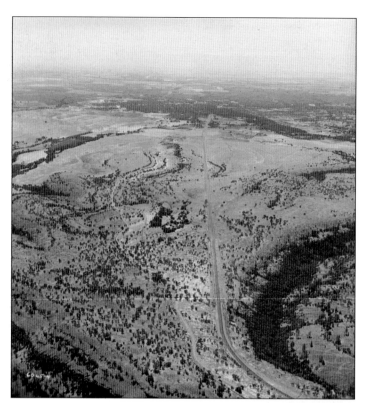

GETTING THINGS STRAIGHTENED OUT. The newly constructed Highway 32 can be seen emerging from the trees of Chico at the top of the photograph, heading five miles uphill to Hog Springs, which would be just beyond the bottom of the picture. The old Humboldt Road is seen here winding across the landscape to the left of the new road. (Courtesy of John Nopel collection.)

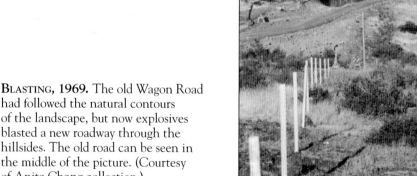

BLASTING, 1969. The old Wagon Road had followed the natural contours of the landscape, but now explosives blasted a new roadway through the hillsides. The old road can be seen in the middle of the picture. (Courtesy of Anita Chang collection.)

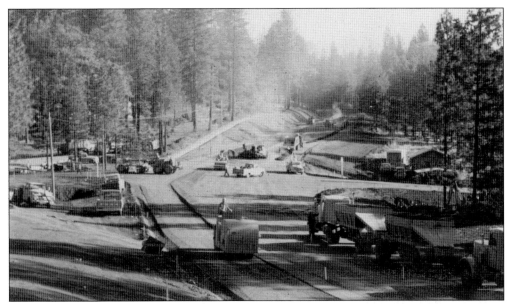

CONSTRUCTING HIGHWAY 32. The 1969 construction is taking place at what would later be called Nopel Avenue in Forest Ranch. Many workers, and even their families, lived temporarily in two trailer parks that sprang up in Forest Ranch. These trailer parks remained after the workers completed their jobs. (Courtesy of Anita Chang collection.)

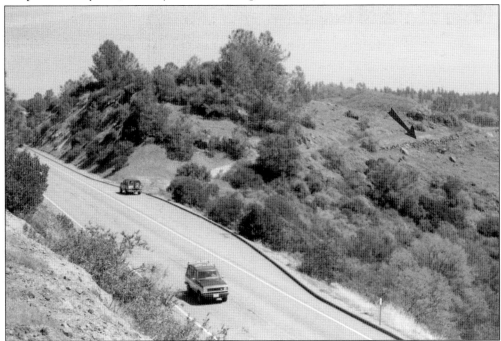

TRACES REMAIN. The realignment of the old road from Chico to Lomo was carried out over more than 12 years. When it was completed in 1970, a new era began. The road was now called Highway 32, and the old name of Humboldt Road began to fade. The arrow points to old road construction near the former 14-Mile House and shows how the new highway often bypassed what used to be landmarks on the old Road. (Courtesy of Anita Chang collection.)

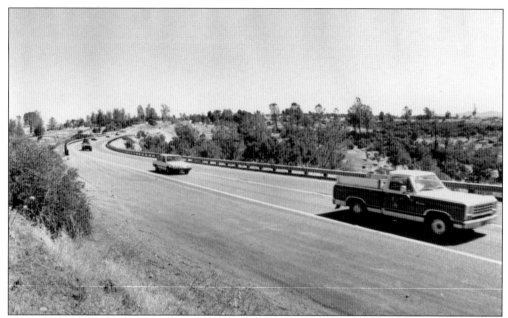

MODERN TIMES. Highway 32 offered a modern, high-speed roadway through the mountains to Forest Ranch, Lake Almanor, Lassen Volcanic National Park, and points beyond. The late 20th century had met and overlaid the old Humboldt Road. (Courtesy of Anita Chang collection.)

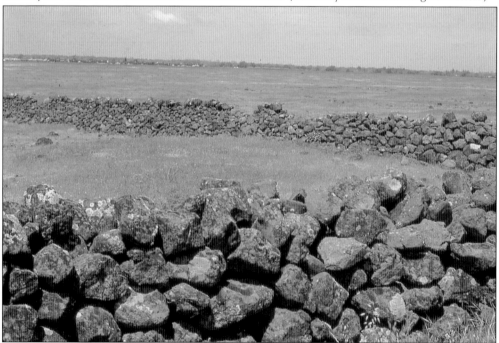

ROCK FENCES. Other remnants of times past can still be seen along today's highway. It was long believed these rock walls were built by Chinese labor as early as the 1860s. More recent research suggests that many, if not most, of the walls in the Chico area were laid by several Portuguese stonemasons. Ranch hands, in their off-seasons, would move the rocks from the open fields to the construction site. (Courtesy of John Nopel collection.)

LOST IN MEMORY. At the modern Junction area in today's downtown Chico, the old name "Humboldt Avenue" still lives on. The gas station in the center of the photograph occupies the site of the Junction or Chico Hotel, shown on pages 20 and 21. The small triangle park, located in the middle left, was the open space where, in times past, horses and wagons turned around. (Courtesy of Anita Chang collection.)

A DISTINCTIVE LANDMARK. In the 20th century, the Humboldt Wagon Road was realigned and improved for automobile use. Sections of the old road were abandoned or paved over. The easily recognizable rock outcroppings of the County Seat Grade, appearing so prominently in the picture on page 2, were bypassed by the new route. Most forgot the history and location. (Courtesy of Anita Chang collection.)

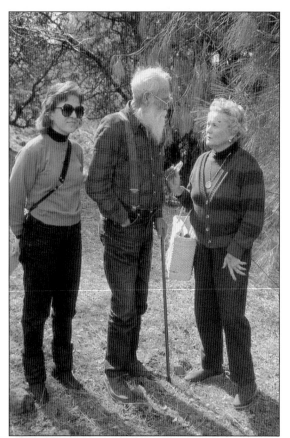

ON THE SEARCH. Dorothy Morehead Hill (right) and Claud Willis (center) descended from local pioneers. Anita Chang (left) was researching the road and discovered Dorothy had been on the County Seat Grade as a child. Anita remembers, "Claud was in a nursing home. Dorothy tied his shoelaces for him so he could come out and show us both where it was." Dorothy established a noted collection of Butte County Native American history. Claud named the roads in Forest Ranch for its early families. (Courtesy of Anita Chang collection.)

REDISCOVERED. Anita Chang sits triumphantly atop the landmark rock. In 1995, the City of Chico acquired a large acreage on the south side of Big Chico Creek to add to Bidwell Park. The brush was cleared. Today's "Humboldt Trail" leads walkers and bicyclists to the rocks and valley views seen from the old wagon road. (Courtesy of Anita Chang collection.)

Forest Ranch

★ PL🜨NET ★

"All the News that fits"

| MCMLXXXI NO. 1 | WEDNESDAY, MAY 13, 1981 | 2 STAR FINAL | FREE |

Welcome to the Planet

With the months of groundwork planning completed it is indeed a pleasure for we, the publishers, to welcome you to the first edition of the Forest Ranch Planet.

Virtually all new projects start with a set of ideas and the project that is the Planet was no exception. We'd like

Forest Ranch Prepares to Fight the Feds

Glossary:

Carcinogenicity (kär-sin-ō-jĕn) any cancer producing substance or agent.

Dioxin (dĭ-ŏx-ĭn) a highly toxic substance produced during the manufacture of phenoxy herbicides.

Neurotoxicity (nū-rō-toks-ĭk) Poisonous or destructive to

that 2,4-D be eliminated from consideration.

The next regular public meeting of the Community Association, April 15th, was attended by the now imbroiled County Supervisor, Hilda Wheeler, the County Commissioner of Agriculture, Joe Bandy (responsible for spraying permits in the county), and members of the Sheriffs Department. That meeting was less heated, but

munities regarding the use of phenoxy herbicides.

At 10:30 the meeting will Commissioner Bandy concluded and another meeting began with the Forest Service, represented by Char Little and Dave Nelson. F cus of the meeting with Nelson and Little was on t location and nature of the sites under consideration treatment with 2,4-D. Als discussed were alternative

THE NEWS. In 1981, about 100 years after Forest Ranch was named, residents had enough history, enough people, and enough going on that the community felt it time to start its own newspaper. The *Planet* was the first edition. Residents still eagerly await the monthly publication of its successor, the *Post*. (Courtesy of John Nopel collection.)

FOREST RANCH COMMUNITY CENTER. The Shuffleton family had donated land for a one-room schoolhouse and land to Forest Ranch. When Chico Unified School District built a new school, the former schoolhouse and land reverted back to Christine Shuffleton Salzman, who wished to sell them for continuing community use. Local realtor Jim Crane helped broker a deal. In 1994, the Forest Ranch Women's Club raised funds to make the purchase, converting the old schoolhouse to the community center. (Photograph courtesy Robert B. Thomas.)

TOWN WITH A HEART. Typical of the small settlements along the Humboldt Road, everyone pitches in. The populations of Forest Ranch, Butte Meadows, and Chester are all less than 2,000 people, yet they boast Lions and Rotary Clubs, churches, community associations, and schools. Lumber jobs are few now. Butte Meadows and Jonesville are still seasonal communities. Residents continue, however, to turn out for good causes. (Courtesy of Forest Ranch Women's Club collection.)

SELF-RELIANT. Recognizing how vulnerable Forest Ranch was to wildfire, around 1979, the Forest Ranch Women's Club achieved its goal to help provide fire protection for the community. Working with the Forest Ranch Community Association and others, the club produced fundraisers ranging from an art show to "penny-a-dip" potlucks. Success shows in this first trained volunteer fire crew, fire truck, and fire station funded by the community. (Photograph courtesy Grover Jones.)

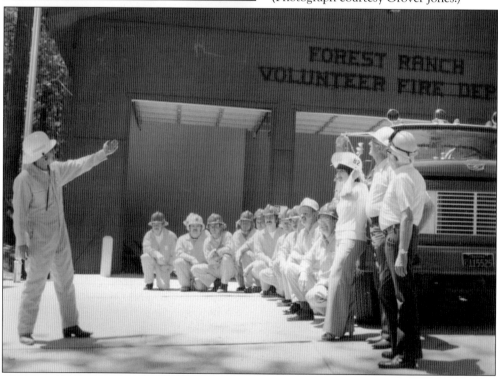

"DOWNTOWN" FOREST RANCH. Six buildings comprise the "commercial" center of today's Forest Ranch. Foothill towns may no longer have blacksmiths, but post offices, stores, and restaurants echo the same kinds of businesses that marked the stops along the historic Humboldt Wagon Road. (Photograph courtesy Robert B. Thomas.)

LIVING WITH WILDLIFE. The largest migratory deer herd in California winters in the Lassen foothills. Residents along the Humboldt Road have reported hundreds of deer at a time passing by their homes in years past. Hunting deer has been a part of life in these communities along with an appreciation for living in a place abundant with wildlife. (Photograph courtesy of Jan Dawson, California Department of Fish and Game.)

REJUVENATION. Marie Potts, Mountain Maidu, was born in Big Meadows in 1895. During her life, she saw the devastation of her people and helped to lead a regeneration of her culture. Seen here in her ceremonial regalia, her headdress is made of flicker feathers. She dedicated her life to preserving her cultural heritage and educating others about the Maidu. Among her many accomplishments, she founded the *Smoke Signal*, the oldest Indian newspaper in America. (Courtesy of Naturegraph Press.)

MECHOOPDA TODAY. The Mechoopda Indian Tribe of Chico Rancheria is federally recognized and operates a housing corporation, economic development corporation, and youth, economic assistance, and health programs. Both the Mechoopda and the Mountain Maidu are working to acquire, restore, and manage undeveloped lands that were home to them in times past. This community center in Chico was built in 2001. (Courtesy of Mechoopda Indian Tribe.)

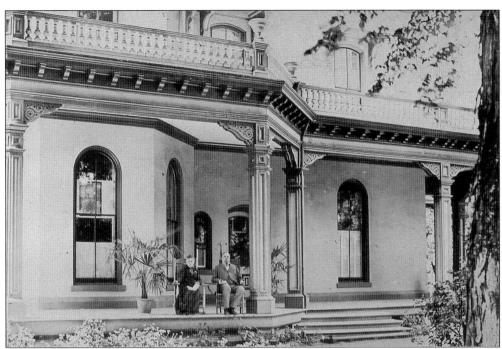

PEOPLE WHO BUILT THE ROAD. John Bidwell had advantages that might have made his successes seem effortless: money, connections, and land. Yet, he suffered significant financial losses, was often unpopular for his political stances, and gave away some of his land to establish Chico. Taking the risk to build the Humboldt Wagon Road may not have paid off as he would have liked, but it has left a rich legacy for those who have followed. (Courtesy of John Nopel collection.)

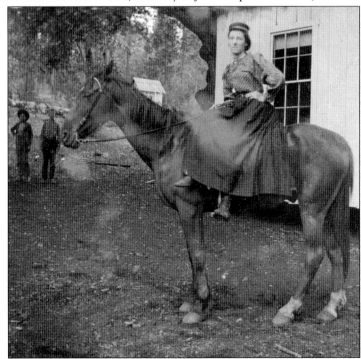

THE ROAD THAT BUILT COMMUNITIES. This picture of Lizzie Wilson Dorrett conveys the independent spirit of all those who have settled along the Humboldt Road. Mail, lumber, and supplies carried on the road brought economic benefit that built communities along its length. Hog Springs, the hotels, West Branch, and Lomo are gone. Chico, Forest Ranch, Butte Meadows, Jonesville, Chester, Westwood, and Susanville remain. (Courtesy of Sara King collection.)

ROAD RUTS. The iron-rimmed wheels of freight wagons and stages on the old Humboldt Wagon Road made these deep ruts as long ago as the 1860s. If one does not know where to look or does not know what to look for, it is easy to miss them and easy to think the trucks and automobiles of today have always been the way to travel the road. (Courtesy of John Nopel collection.)

FOREST RANCH CHARTER SCHOOL. The students at the Chico, Forest Ranch, Chester, Westwood and Susanville schools have a special link to the past through their connection to the Humboldt Road. Perhaps learning about it will inspire them to carry an appreciation and sense of protection for this special road and the places along it. (Photograph courtesy Robert B. Thomas.)

BIBLIOGRAPHY

Bourdeau, Larry Francis. "The Historical Archeology of Cabo's Tavern CA-BUT-712." (master's thesis, California State University), 1982.

Butte Meadows-Jonesville Association History Committee. *A Small Corner of the West.* Chico, CA Butte Meadows-Jonesville Community Association, 2007.

Chang, Anita Louise. "The Historical Geography of the Humboldt Wagon Road." (master's thesis, California State University), 1991.

Gillis, Michael J. and Michael F. Magliari. *John Bidwell and California: The Life and Writings of a Pioneer, 1841–1900.* Spokane, WA: The Arthur H. Clark Company, 2003.

Haase, Cheryl Conrad. *Too Many Irons in the Fire: The life and times of Charles F. Stover and the history of the Ranching families of Tehama, Lassen and Plumas Counties, 1850–2006.* Ed. Mary Lee Grimes Red Bluff, CA: 2005.

Hutchinson, William H. *California Heritage: A History of Northern California Lumbering.* Chico, CA: Hurst & Yount, 1956.

McIntosh, Clarence F. "Stage Lines From Southern Idaho to the Sacramento Valley, 1865–1867." *Idaho Yesterdays.* Idaho Historical Society, Fall 6.3 (1962).

Oakland Museum. *California: A Place, A People, A Dream,* Oakland, CA: Chronicle Books, 1986.

Ogle, Beverly Benner. *Whisper of the Maidu: My Indian Ancestors of the HumBug Valley.* Self-published, 1998.

————*Spirits of Black Rock: Firsthand Memories of Growing Up in the Mill Creek Area of Northern California; the Landscape and its Inhabitants.* Paynes Creek, CA: self-published, 2003.

Potts, Marie. *The Northern Maidu.* Happy Camp, CA: Naturegraph Publishers, Inc., 2007.

Rogers, David J. "Theodore Judah and the Blazing of the First Transcontinental Railroad Over the Sierra Nevadas." (Rogers/Pacific, Inc., and Department of Civil and Environmental Engineering, University of California, Berkeley, n.d.) 4–10, 22–23.

Roney, Emma and George. *Treasured Memories and a Little B.S.* Chico, CA: Heidelberg Graphics, 2005.

Stephens, Kent. *Matches, Flumes, and Rails: The Diamond Match Company in the High Sierra.* Corona del Mar, CA: Trans-Anglo Books, 1977.

DISCOVER THOUSANDS OF LOCAL HISTORY BOOKS FEATURING MILLIONS OF VINTAGE IMAGES

Arcadia Publishing, the leading local history publisher in the United States, is committed to making history accessible and meaningful through publishing books that celebrate and preserve the heritage of America's people and places.

Find more books like this at
www.arcadiapublishing.com

Search for your hometown history, your old stomping grounds, and even your favorite sports team.

Consistent with our mission to preserve history on a local level, this book was printed in South Carolina on American-made paper and manufactured entirely in the United States. Products carrying the accredited Forest Stewardship Council (FSC) label are printed on 100 percent FSC-certified paper.

MADE IN THE USA